MURDER & MAYHEM IN
INDIANA

MURDER & MAYHEM IN
INDIANA

KEVEN McQUEEN

THE
History
PRESS

Published by The History Press
Charleston, SC 29403
www.historypress.net

First published 2014

Manufactured in the United States

ISBN 978.1.62619.368.0

Library of Congress CIP data applied for.

To Amy and Quentin.

Contents

Acknowledgements

Geneta Chumley; Thomas Clark; Drema Colangelo; Greg Dumais and everyone at The History Press; Gaile Sheppard Dempsey; Eastern Kentucky University Department of English and Theatre; Eastern Kentucky University Interlibrary Loan Department (Stefanie Brooks; Heather Frith; Pat New; Shelby Wills); Amy and Quentin Hawkins; Darrell and Swecia McQueen; Darren, Alison and Elizabeth McQueen; Kyle and Bonnie McQueen; Michael, Lori and Blaine McQueen and Evan Holbrook; Lee Mitchum; Jerica Nanik; Mia Temple. Also: the Provider.

This book was edited by Lee Mitchum.

1

The Mystery of Dr. Knabe

The slaying of Helen Knabe in Indianapolis contains the elements that make true crime stories fascinating: the puzzling, pointless and grisly homicide of a prominent individual; a bungled investigation; legitimate clues and red herrings; a cast of bizarre characters; absurd theories; and, most of all, a genuine sense of mystery.

The tragedy of Knabe's premature demise is all the more striking because she must have been a truly remarkable person. She succeeded despite obstacles that would have made many people surrender out of sheer despair. Born a German peasant around 1876, as a young girl she denied herself the necessities of life, including food, in order to save enough money to travel to the United States. Once there, she was handicapped in that she could not speak a word of English. She went to work for an Indianapolis physician as a "house girl of all work"—that is, she was a maid, a cook, a manual laborer and an all-purpose drudge. But she was intelligent and had a keen interest in medicine and science. Through perseverance and hard work, she learned English, saved her money and entered the Medical College of Indiana, an institution that readers of my book *Forgotten Tales of Indiana* will recognize as one of the patrons of professional ghoul Rufus Cantrell's peculiar services.

Knabe proved such a brilliant student that she became an instructor in bacteriology and pathology even before she graduated in 1904. For a year after graduation, she was in charge of the school's laboratory. She rose to the position of assistant pathologist in the state board of health's lab and became Indiana's first official state bacteriologist. In 1906, she

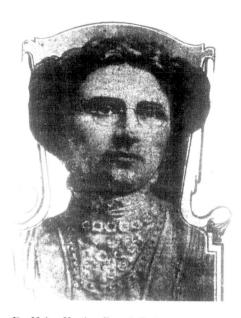

Dr. Helen Knabe. *From the* Indianapolis Sun, *October 26, 1911.*

was named assistant in physical diagnosis at the Medical College of Indiana. On November 1, 1908, she resigned and started her own private practice. In January 1909, she was elected a member of the faculty at the Indiana Veterinary College, where she served as chair of parasitology and hematology. By the time of her death at age thirty-five, she had a roster of upper-class patients in Indianapolis.

Female doctors were relatively rare in Knabe's time; according to the book *The Sum of Feminine Achievement*, in 1910, there were precisely 13,687 in the United States. On the night of October 23, 1911, their number decreased by one. At 8:00 a.m. on October 24, Dr. Knabe's assistant, Katherine McPherson, unlocked the door to the physician's ground-floor rooms at the Delaware, a swanky apartment house where Knabe lived and kept her office. The doctor did not answer McPherson's calls, so McPherson commenced a room-to-room search. McPherson found her employer's body on a blood-soaked bed in the sleeping quarters. Then, she did something that has caused many an open-and-shut murder case to go unsolved forever: rather than call the police right away, the rattled woman called some of the doctor's friends and relatives, many of whom showed up to see the remains for themselves. Despite their good intentions, they contaminated the crime scene. More than an hour after discovering the body, McPherson finally notified the authorities.

When detectives arrived, they noticed that the doctor's nightdress was in disarray. Her throat was cut so deeply from ear to ear that she had nearly been decapitated. The furniture in the rest of the apartment was in order, so whatever had happened to Dr. Knabe occurred in her bedroom with great swiftness. But one item was known to be missing: a surgical instrument called a microtome, loaned to Knabe by Dr. C.E. Ferguson. The theory quickly gained ground that it was the murder weapon.

In some respects, Dr. Knabe's death is reminiscent of the baffling 1929 murder of Isidor Fink in New York City's Harlem. As in the Fink case, all of the apartment's doors were locked from the inside. The windows were closed and locked in all rooms but the doctor's bedroom. There, the windows were up but the screens were intact. The sills were coated with thick dust from street traffic, proving that no one had entered or exited through the windows. The only access into the apartment seemed to be via a dumbwaiter that was too small to hold a man. The front door was secured with a spring mechanism that would automatically lock the door when it was closed; therefore, it was entirely possible for a keyless intruder to lock the door behind him while leaving. The mystery was how Knabe's assailant got into the apartment in the first place.

Coroner C.O. Durham and detectives questioned janitor Jefferson Haynes, who also happened to be an elder at Shiloh Baptist Church; Haynes's daughter, Eva; and a housekeeper named Fannie Winston, all of whom lived in basement rooms under Knabe's apartment. Haynes claimed he had heard the sound of someone falling in the night, followed by a scream and a groan. He assumed the noises were being made by one of the doctor's patients and went back to sleep. He told the story to detectives several times but contradicted himself as to exactly when he heard the sounds. The coroner opined that it was impossible for Dr. Knabe to have groaned, so deep was the cut in her throat. Neither Haynes's daughter nor Mrs. Winston had heard any noises in the night. The police were suspicious of Haynes and detained him.

By the day after the body was discovered, the police were divided into two camps. Coroner Durham embraced what we might call the Obvious Theory: he felt that Knabe had been murdered, as evidenced by a defensive wound on her left forearm and her throat wound, which was so deep the blade had grazed the spinal cord. By contrast, Captain William Holtz, chief of detectives, adhered to the Barely Plausible Theory: he thought that Dr. Knabe had committed suicide. As a doctor, he argued, she would have known how to do maximum damage to her own throat with a knife slash. As a trained gymnast, she could have put up a fight against an assailant, yet the furniture was undisturbed. There was no discernible motive for murder; she had been neither robbed nor raped. On the other hand, she had gone into considerable debt after opening her private practice and had worried about her financial predicament. Even her furniture and medical instruments were not her own, but the property of her cousin Augusta Knabe.

The doctor's friends countered that she had often railed against suicide as a cowardly act and pointed out the most glaring flaw in the suicide theory:

no knife had been found on the premises. How could Dr. Knabe have given herself such a ghastly injury, capable of causing near-instantaneous death, and managed to dispose of the weapon? Detective Holtz responded that since some of the doctor's friends had come by the apartment before the police arrived, perhaps one of them, wishing to spare the doctor the stigma of suicide, had taken the knife. Katherine McPherson and Augusta Knabe denied taking anything from the crime scene.

The police spent the best part of a day searching the entire apartment building, going through Knabe's correspondence and questioning all occupants of the flat as well as grilling delivery boys and janitors of neighboring buildings. On October 26, the first real clue turned up: a barkeeper named Joseph Carr told the police that he had been walking home around 1:00 a.m. on the night of the murder, a route that led him past the Delaware apartments. As he approached the building, he heard two screams, the second more muffled than the first; then, a man exited the building's back alley and ran up the sidewalk toward Carr. When the stranger realized he had been seen, he whipped a handkerchief out of his pocket and covered his face with it. The man dashed into the night, heading south on Delaware Avenue. (Carr's insistence that he heard two screams supported the story told by Jefferson Haynes, so hopefully Haynes was detained by the police no longer.)

Carr had had only a fleeting glimpse of the mysterious man but thought he was about forty years old and well dressed in a dark suit and a stiff hat. At first, police thought Carr's story improbable, but when they reenacted the scene according to his description, they found that it was possible for a man to leave Knabe's apartment and reach the back alley in the allotted time if he fled immediately after slashing the doctor's throat. Detectives—at least the ones who did not think it a suicide—believed the mysterious man might have been a physician or a patient who attacked Dr. Knabe as she slept. That theory had problems. Had the man hidden in the apartment until she went to sleep? If so, how did he get inside, since it was clear no one had entered through the windows? It was more reasonable to believe that Dr. Knabe, for whatever reason, had allowed the man inside. The authorities were quick not to cast aspersions on the late doctor's character. Detective Holtz told the press that "Dr. Knabe's reputation was unblemished, and she lectured to young women and men on the necessity of social purity as well as on physical culture and hygiene."

Bartender Carr's statement jogged the memory of two citizens, who stepped forward with corroborating stories of their own. A man claimed

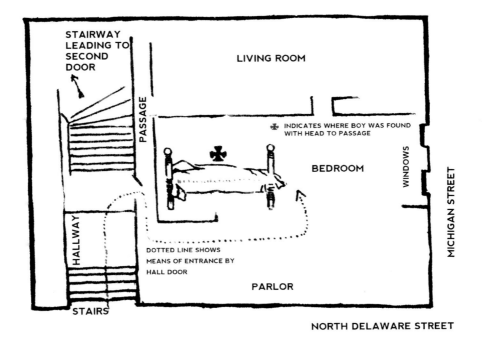

STAIRWAY
LEADING TO
SECOND
DOOR

LIVING ROOM

PASSAGE

✠ INDICATES WHERE BOY WAS FOUND
WITH HEAD TO PASSAGE

BEDROOM

WINDOWS

MICHIGAN STREET

HALLWAY

DOTTED LINE SHOWS
MEANS OF ENTRANCE BY
HALL DOOR

PARLOR

STAIRS

NORTH DELAWARE STREET

Sketch of Dr. Knabe's apartment. *From the* Indianapolis Sun, *October 24, 1911.*

that about eight o'clock on the evening of the murder, he was stopped by a man on the street who asked for directions to the Delaware apartments. He was dressed exactly like the man Carr described. A woman who lived along the route on which the man allegedly escaped said that she heard someone running past her house around the time the suspect fled from Carr. Judging from the sound of the footsteps, the person was running from the vicinity of the Delaware apartments.

As Dr. Knabe's body was carted to Crown Hill Cemetery, Indianapolis was invaded by detectives from other cities, working independently from the police. They allegedly were hired by doctors who feared the killer was one of their own or a deranged patient of the slain physician. After running down "twenty or thirty clues," according to the press, the stumped local detectives returned to the barely tenable suicide theory. They grilled the victim's cousin Augusta for three hours on October 29, the tenor of their questions leaning toward the notion that Helen had cut her own throat and some busybody had removed the knife from the scene. Many of her answers were incoherent, and she was so nervous that investigators had to

give her frequent breaks and medicinal stimulants. She did no better when testifying before the coroner a couple days later. Nevertheless, detectives were convinced after her performance that Miss Knabe knew more than she was telling.

An acquaintance of Helen Knabe's, Dr. W.T. Dodds, was adamant that she had committed suicide. His reasons for believing so were not compelling. "Dr. Knabe was an arrogant, headstrong and merciless woman, whose ambition to succeed in the world was so great that to achieve it she did not hesitate to sacrifice anyone," he said. "During her connection with the State Board of Health, Dr. Knabe made herself so disliked that she was asked to resign…She was a bright and intelligent woman, but she failed in her wish to sweep things before her." However, Dr. Dodds's negative character assessment cut two ways (pardon the pun): had Knabe been so arrogant, merciless and disliked, those might be reasons for someone to murder her. Dr. Dodds scoffed at the idea that Knabe, as a physician, might be expected to have opted to end her life with drugs or some other painless method: "That kind of death would not appeal to her. She wanted something violent, in keeping with the struggle she had made for success in her profession." In other words, Dodds thought she chose a painful and gruesome means of suicide over a painless one because she liked its symbolic value. When asked to explain the defensive wound in Knabe's forearm, Dr. Dodds claimed, "It would seem natural for Dr. Knabe deliberately to cut into her arm to test the weapon or to ascertain what pressure was necessary." Well, it seemed natural to Dr. Dodds, anyway.

The suicide theory was farfetched, but it was deductive brilliance equal to a Hercule Poirot compared to other pet theories that made the rounds. Coroner Durham found among Dr. Knabe's correspondence a letter in which she expressed an interest in Buddhism. Durham refused to explain why he found this significant, but it seems he thought a vicious Buddhist had come after the doctor for reasons undisclosed. The hypothesis was abruptly dropped and never mentioned again. Another somewhat less-than-brilliant supposition came from a female physician, Dr. Carrie Gregory of Elwood, Indiana, who believed Knabe's death was neither suicide nor murder, but the ultimate result of the Hippocratic oath's injunction to "apply, for the benefit of the sick, all measures which are required" being taken to foolhardy lengths. Dr. Gregory stated that a certain female patient had been suffering from "an ailment that was drying up the blood" and that Dr. Knabe was convinced a transfusion of blood from a healthy person would save her. Knabe attempted to prove her point by donating two quarts of her own

blood but died during the attempt. The other physicians present during the procedure took the sensible precaution of nearly decapitating the dead Dr. Knabe to make it look as though she had been murdered and then placed her body on her bed. Dr. Gregory claimed that the patient had been saved by Dr. Knabe's heroic sacrifice and was recovering in an Indianapolis hospital. Despite an investigation, the patient never turned up. Newspaper readers were entertained with this sort of folderol for a couple months.

Coroner Durham announced his official verdict a few days after Christmas: Dr. Knabe was murdered. The coroner's statement was all the progress that was made in the case for several months. The police ran out of clues, and the case went cold. Some detectives continued to retain a fondness for the suicide theory despite the improbability of the victim's nearly severing her own head with a knife or razor.

But the Indianapolis chapter of the Council of Women did not give up. Its president, Dr. Amelia Keller, had been a friend of Dr. Knabe's, and she made it a personal mission to find the killer. The council hired a private detective named Harry Webster to keep working the case. It seemed for a time that the Council of Women had wasted its time and money by hiring Webster because he uncovered no clues to speak of. Nobody held out much hope, but suddenly, the mystery was catapulted back into the headlines with a voluntary confession.

About two weeks before the *Titanic* went down, police in Portsmouth, New Hampshire, arrested a drunken young navy sailor named Seth Nichols. The influence of the grape made Nichols very talkative, and he told the authorities that a well-dressed man he knew only as "Knight" had paid him $1,500 to desert the USS *Dixie* and murder Dr. Knabe. He maintained that he had been in Indianapolis visiting his sister, Mrs. Grace Blakeman, when he met the iniquitous Knight at the Washington Street skating rink. (The reader is invited to relish the improbability of such murderous fellows hanging out in a skating rink.) Nichols claimed to be tormented by guilt and in constant terror of being caught by the police, and he seemed almost relieved to be arrested. He dropped a hint that he would not even mind receiving a death sentence.

The authorities were delighted to have an arrest and a confession, but Nichols's story immediately fell asunder at nearly every joint. He provided police with details about the murder but told them nothing that could not have been gleaned from reading the daily papers. Other details could be neither proved nor disproved, such as Nichols's contention that he and Knight had slipped into Dr. Knabe's apartment together on the night of

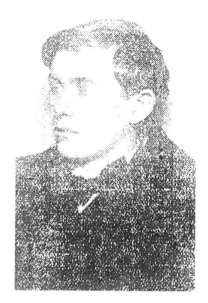

Seth Nichols, who confessed to the murder of Dr. Helen Knabe. *From the* New Orleans Picayune, *April 8, 1912. Courtesy of the* New Orleans Times-Picayune.

the slaying. Nichols contradicted himself: initially, he claimed he left Indianapolis the day after the murder, but later, he said he waited three days. Unsavory details of his background surfaced: he had married Mary McHale, a seventeen-year-old mill girl of Pawtucket, Rhode Island, on November 6, 1911, a week after the murder. They were married only three months, Mary having decided to end her life in her sister's Boston home with a dose of mercury on March 11, 1912. That was bad enough, but the Boston police charged Nichols with robbing the house where his bride of three months had died.

Nichols had said that he was visiting Grace Blakeman when he murdered Knabe, but Mrs. Blakeman told the press that Nichols had not been in Indianapolis at the time he claimed. His aunt, Mrs. Glenn Gilbert of Lafayette, Indiana, said that Nichols had suffered a head injury as a child, and afterward, he had never been mentally right. He had a marked tendency to lie and exaggerate. Nichols had said that his dastardly employer Mr. Knight lived in Wonderland Park on North Washington Street, a lie easily run to earth. The final blow came from the commander of the USS *Dixie*, whose records proved Nichols had been aboard the day of Knabe's murder. He was not even a deserter, but rather had been dishonorably discharged "for conduct prejudicial to the service" on December 20, 1911. Not wishing to surrender his moment of shabby glory, Nichols feebly claimed that he and Knight had bribed the ship's records keeper into counting him present while he went on unauthorized shore leave.

The grand jury met again in April 1912 but, like the former grand jury, failed to vote a true bill of murder. When Nichols's claims were shattered, the investigation into the murder of Dr. Knabe ground to a halt. Nothing more was heard of the case until Christmastime 1912, when, once again, the suicide theory came to the fore. This time a grand jury met and debated the issue. The jury decided once and for all on a verdict of murder after hearing a critical piece of evidence that somehow had been overlooked

repeatedly: a large bloody handprint, not Dr. Knabe's, was on the doctor's pillow. The clue revived interest in the case. The Council of Women, led by the indefatigable Dr. Amelia Keller, continued to agitate, and Detective Webster kept searching. Dr. Keller offered a $2,500 reward for information leading to the conviction of Dr. Knabe's murderer.

In December 1912, Detective Webster presented his findings to the grand jury and, at long last, came two arrests and two indictments. Dr. William B. Craig, president of the Indiana Veterinary College, where Dr. Knabe had been a faculty member, had been Knabe's unacknowledged suitor; he had given her rides in his auto, and they had often been seen together. On this—and one hopes, stronger—evidence, the police brought him into custody, along with an undertaker named Alonzo Ragsdale. Craig was charged with murder, Ragsdale with helping to conceal evidence after the fact.

Dr. Craig appeared in criminal court on the last day of the year and was set free on a $15,000 bond. Ragsdale paid his bond on New Year's Day. The indictment against Ragsdale came as a surprise, but for quite some time, Dr. Craig had been a "person of interest in the case," as cops say when being diplomatic; he had been questioned for several hours when the grand jury had met back in April.

There was plenty of evidence concerning the formerly close relationship between Drs. Craig and Knabe. They had met in 1908 while she was the bacteriologist for the state of Indiana. In 1909, Dr. Craig placed her on the faculty at his veterinary college, but at some point, the romance became stormy. Dr. Knabe had been "a persistent visitor" at Dr. Craig's home for the two weeks preceding her murder. One night, the housekeeper overheard an argument between the doctors concerning their proposed marriage. Dr. Knabe had said, "You can continue to practice and I can continue to practice," which sounds as if Dr. Craig expected her to give up her career if they got married. Knabe had visited the Craig residence on the night of her death, but only to return a book she had borrowed. Dr. Craig was not at home at the time. None of this was very serious evidence, but a witness named Harry Haskett claimed to have seen Dr. Craig stepping out of the Delaware apartments a little after 11:00 p.m. on the night of the murder. He had been able to pick the doctor's photo out of a group of portraits. Of course, this does not jibe with the previously described 1:00 a.m. encounter between Joseph Carr and the man with the handkerchief on his face, raising the possibility that the murderer invaded the apartment after Craig visited Knabe.

Ragsdale, the undertaker, had been the administrator of Dr. Knabe's estate and owned a silk kimono that had belonged to the doctor. An analysis

showed that it had been stained with human blood and washed in "a strong chemical solution." His accusers thought he had removed the garment from the house at the insistence of the alleged murderer, Dr. Craig, leaving unanswered the question of why Craig didn't just do it himself. Ragsdale explained that he owned many of Dr. Knabe's effects that were considered to be of little or no value, including the kimono. It is hard to believe that if Ragsdale had helped Dr. Craig commit a perfect murder, he would be foolish enough to keep such an incriminating piece of evidence. Dr. Knabe's body had been clad in a nightdress rather than the kimono, and Augusta Knabe and Katherine McPherson swore that the kimono had not been in the room with the body. Perhaps the killer thought it convenient to wipe his bloody hands on the kimono and then discarded it in another room while escaping.

The prosecution probably realized the shakiness of its case, for though the trial of Craig and Ragsdale was supposed to begin on June 23, the state asked that it be postponed until October. Craig's trial did not actually get underway until November 28, when the dramatis personae convened in Shelbyville. (It was decided to try Ragsdale later.)

The case against Craig was made up of suspicious circumstances that may be easily summarized. His association with Dr. Knabe had been souring in the weeks before her death. Judging from arguments heard by witnesses, he had wanted to break off the relationship. The prosecution contended that Dr. Craig had been seeing another woman who lived in Avon, Indiana. The other evidence included the word of the aforementioned Harry Haskett, who claimed he had seen Dr. Craig leaving Knabe's apartment building on the night of the murder. Dr. Eva Templeton told Detective Webster that Dr. Craig had returned home late that night and had changed his clothes; but Dr. Templeton heard this from the Craigs' housekeeper, so the information was secondhand. Nevertheless, Detective Webster was certain he had collared the right man. The Council of Women agreed and employed "several of the best criminal lawyers in the state" to assist in Dr. Craig's prosecution. The state's lawyers promised not to seek the death penalty.

On December 3 came one of the pivotal moments of the trial. Harry Haskett had seemed very confident that he had witnessed Dr. Craig in the act of fleeing Dr. Knabe's apartment, but once on the stand, he faltered and refused to positively identify Dr. Craig. Worse, three witnesses testified that they heard a scream issuing from the apartment after midnight. To believe Haskett had seen a homicidal Dr. Craig leaving the Delaware at 11:00 p.m. was to believe that Dr. Knabe had waited over an hour after her throat had been cut to start screaming.

Notably lacking in accounts about the trial are mentions of the bloody handprint found on Dr. Knabe's pillow. Had the print matched either Craig or Ragsdale, it alone would have made the prosecution's case. At least Seth Nichols was not invited to testify.

The defense was so certain of acquittal that it made a motion to dismiss the case the moment the prosecution closed. Craig's attorney, Henry Spaan, claimed that the state had failed to build a case against the doctor. The judge agreed, and on December 9, he instructed the jury to dismiss the case. On the same day, an Indianapolis prosecutor had the indictment against Alonzo Ragsdale nolle prossed (a noble Latin phrase that means, legally, "forget about it").

And that was the end of the Knabe case, probably forever. No one else was ever arrested or tried; no more evidence surfaced; no one made a deathbed confession. The story dropped from the papers and consequently from the mind of the public. Even the Council of Women finally gave up. We are left only with unanswered questions and the faint memory of a woman who, in a better world, would be remembered for her determination and accomplishments rather than for her unsolved murder.

2

Picnic of Death

In the early days of the Great Depression, the prosperous Simmons family lived in Simmons Corners near Greenfield. Every year, they met for a combination reunion and picnic. They chose to have their 1931 meeting at Memorial Park in Lebanon, sixty-five miles away, on June 21, the first day of summer. No doubt it seemed impossible to them, as it would to most, that anything evil could come from such a wholesome, harmless event.

Yet owing to the fallen nature of man, evil cannot be excluded from any event, not even a picnic. A guest noticed that a chicken sandwich included an extra ingredient: capsules full of mysterious white powder. He immediately left the park and took the item to a local doctor to see what was in it. The physician, who didn't seriously test the powder, guessed that it *might* be quinine, an antimalarial painkiller. But even if the substance had been relatively harmless quinine, why were capsules of it in the sandwich?

The attendee hurried back to the picnic, but in his absence, five persons had done a foolhardy thing: they ate the sandwiches anyway, capsules and all. In short order, the five were miserably ill and rushed to a local hospital. Three survived: Lester Carr, Horace Jackson and a wealthy farmer named John W. Simmons. Mr. Simmons's daughter Alice Jean, age ten, died fifteen minutes after she arrived at the hospital, and another daughter, fourteen-year-old Virginia, passed away in the evening. The only other casualties of the picnic were blackbirds that expired after eating crumbs from the sandwiches.

On the day the girls died, Lebanon's coroner, G.A. Owsley, determined that there were only two opportunities for the poison—later found to be

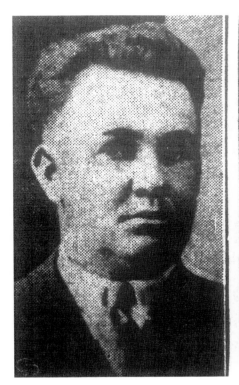 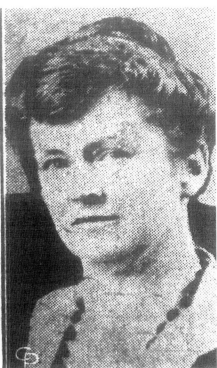

Mr. and Mrs. Simmons. *From the* Lebanon (IN) Reporter, *June 25, 1931. Courtesy of the* Lebanon Reporter.

strychnine—to be placed in the sandwiches. "Once was when they were made," he told reporters, "and the other time was when the family stopped and left the automobile for more than an hour outside the home of Isaac Pollard, a distant relative here [in Lebanon]."

Naturally, suspicion fell on Carrie Barrett Simmons, mother of the two deceased girls and maker of the offending sandwiches, who protested that she had no idea how the capsules got into them. Investigators found that strychnine had been sprinkled on the sweet pickled beets, which Mrs. Simmons also had prepared.

Carrie Simmons was at home in Simmons Corners on June 29, grieving over her lost daughters and being consoled by friends, when police entered and arrested her. She went without protest.

On July 3, Mrs. Simmons was indicted on the charge of murdering her daughters. There were obvious logical problems with this theory that would

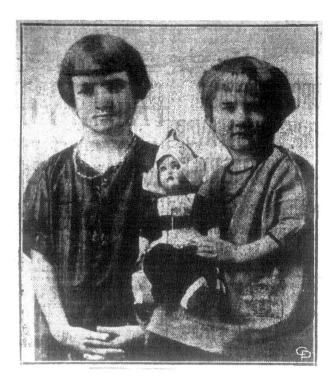

Virginia and Alice Simmons. *From the* Lebanon (IN) Reporter, *June 25, 1931. Courtesy of the* Lebanon Reporter.

present challenges to a prosecutor. Of the eighteen sandwiches she made for the picnic, twelve were poisoned. If she had plotted to kill her daughters in such a bizarre fashion, how could she be sure that they would take one of the contaminated sandwiches? How could she prevent someone she *didn't* intend to murder from eating one? In fact, three persons other than her daughters did consume the food and nearly died. The lack of subtlety in the killer's chosen method was naïve, almost darkly comical; could any sensible person actually believe that capsules in a sandwich would not be noticed? (Indeed, as already noted, one picnicker did see the capsules in his sandwich.) Perhaps the would-be killer surmised that any resulting deaths would be blamed on food poisoning caused by hot summer weather—but it would not take a mental colossus to realize that there would be plenty of leftover evidence in uneaten sandwiches and in the bodies of the victims.

Despite these nagging questions, Mrs. Simmons was the most likely suspect and went on trial in Lebanon on two charges of first-degree murder on September 27, after spending three months in jail. Perhaps that stretch in a cheerless cell made her long for fashionable clothes, because she entered the

courtroom wearing the height of feminine fashion circa autumn 1931. Her husband had bought her black oxford shoes and an Empress Eugenie hat. Her family and most of her Hancock County neighbors expressed steadfast confidence in her innocence, but the situation was serious: she could go to the electric chair.

It appeared from the beginning that the state did not have much, if any, evidence against Carrie Simmons other than that she prepared the chicken sandwiches. Prosecutors were also hampered by their inability to produce even the ghost of a motive, financial or otherwise, as to why Mrs. Simmons might desire to send her girls to an early grave.

On October 1, the state called John Simmons to testify as a reluctant witness against his own wife. Two hours of questioning produced little information that benefited the prosecution, which attempted to show that Mrs. Simmons had tried to poison her daughters two weeks *before* the picnic.

Not much of interest happened at the trial until October 12, when Indianapolis druggist Charles Friedman testified that Mrs. Simmons had purchased sixty grains of strychnine at his store on June 18—which, if true, suggested that Mrs. Simmons must have had tremendous faith in her murderous abilities if she bought so much poison only three days before committing very public murder and still thought she could fool the authorities. Friedman said the transaction stood out in his mind because it had been the first sale of that particular poison he had made in years. This seemed plenty incriminating, but on October 14, Louise Robinson of Bargersville testified that *she* was the person who had bought the strychnine from the druggist. In fact, said Robinson, when she had confronted Friedman he recognized her as the actual purchaser and urged her to testify in favor of Mrs. Simmons. Robinson's testimony was considered so decisive that after she left the stand, a weeping Mrs. Simmons shook her hand, saying, "You have saved my life."

The trial seemed to have more than its share of testimony from less-than-reliable druggists. Another was Harry Short of New Palestine, who claimed under oath that Horace Jackson, Mrs. Simmons's brother-in-law, had bought sixty grains of strychnine at *his* pharmacy a few days before the picnic. The reader will recall that Jackson was one of the three men who barely survived eating the deadly sandwiches, so if Short's testimony were true, it had to mean that Jackson *poisoned himself as well as the Simmons sisters.* Under cross-examination, the formerly positive Harry Short admitted he was "not positive" Jackson was his customer after all.

On October 15, the jurors heard from Mrs. Claude White of Charlottesville, a housewife who was so interested in the case that she

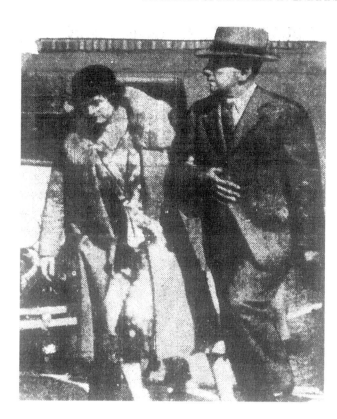

Mr. and Mrs. Simmons arriving at the courthouse. *From the* Lebanon (IN) Reporter, *September 30, 1931. Courtesy of the* Lebanon Reporter.

conducted an experiment that was neither scientific nor rigorous but interesting nevertheless. Using the Simmons family kitchen as a lab, she made twelve chicken sandwiches and put strychnine capsules in six of them. Then at the Pollard house in Lebanon, where the Simmonses had stopped for over an hour on June 21 on the way to the reunion, she put capsules in the other six. After waiting slightly over an hour, she drove to Memorial Park and examined the food. In the six sandwiches that were poisoned in the kitchen, the strychnine capsules had nearly dissolved; but in the six poisoned at the Pollard house, the capsules were almost intact. And since the sandwiches that killed the girls contained visibly whole capsules, this suggested that whoever tampered with the food did so at the Pollard residence.

Carrie Simmons's sixteen-year-old daughter, Elizabeth, testified on October 22 that she personally witnessed her mother making the chicken sandwiches and saw her add no untoward ingredients.

Near the end of the trial, the defense provided evidence that the police had questioned Mrs. Simmons with loud, abusive language late on the night

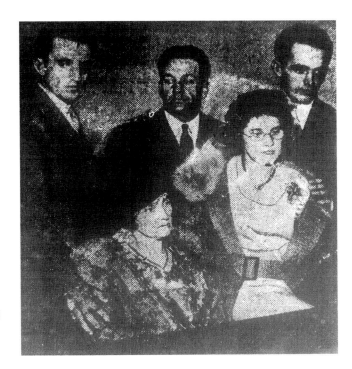

The Simmons family in the courtroom; Mrs. Simmons is seated at the table. *From the* Lebanon (IN) Reporter, *November 6, 1931. Courtesy of the* Lebanon Reporter.

when they arrested her and for several days following. They contended that this was the verbal equivalent of third-degree interrogation.

The trial's highlight came on October 27, when Carrie Simmons took the stand. She said nothing that incriminated herself. The case was given to the jury on November 3; forty-eight hours and nine ballots later, the hopelessly deadlocked members voted eight to four for acquittal.

The hung jury was dismissed, and Carrie Simmons was taken back to jail. Usually in such a case, there is a second trial later. But at some point, attorneys representing the state must have realized that they did not have a winnable case. In May 1933, all charges against the farm mother were officially and finally dropped.

The poisoning of the Simmons girls, dubbed by the press as "the state's most baffling murder case," will probably remain forever a mystery. What makes the case so puzzling is the very narrow window of opportunity to commit the crime. If Mrs. Simmons were innocent and did not add strychnine to the sandwiches—and it appears that she didn't—there were only a few other (rather improbable) ways the poison could get there. Did some unknown person have a grudge against the John Simmons family? If

so, this person must have seen the family car at their relative Isaac Pollard's house in Lebanon—not back home in Hancock County, as the capsules had not had sufficient time to dissolve; he must have contaminated the sandwiches and pickled beets on the spot, using a supply of strychnine capsules that he just happened to have with him, if we assume that most people don't walk around with a handy supply of deadly poison; and he did this while hoping no one witnessed him meddling with the food.

3

The Farmhand and the Acrobat

First let's meet the murder victim. She was Alice Martin, fifty-two years old, unmarried and famously grouchy with the hired help. She lived in a miserable shack incongruously located on gorgeous property: a sprawling 150-acre farm atop a bluff four miles from Derby, overlooking a spectacular view of the Ohio River. It was near the spot where Abraham Lincoln had once operated a Kentucky-to-Indiana ferryboat before he realized he was meant for greater things.

Martin was a woman with a mysterious past. She had been a professional acrobat and aerialist for years under the exotic name Alice de Garno (de Garmo in some accounts). Her specialty was swinging on the trapeze, and she worked on the vaudeville circuit and for the Barnum and Bailey Circus; she traveled with the show in the United States, Europe, Canada and South America. A March 18, 1911 article in the *New York Clipper*—a newspaper that specialized in entertainment-related news—suggests that part of her appeal was that she undressed for success: "Alice de Garno, of aerial disrobing fame, was the added attraction and was well applauded. This lady does some good stunts on the trapeze, her disrobing part being one of the many."

Around 1924, Alice retired from circus life. In 1929, upon the death of her father, William F. Martin, she moved into the family's bluff-top farm for the few remaining years of her life. Perhaps as a reaction to having spent years soaring above lascivious crowds, she now craved seclusion. She lived by herself in her ramshackle house, far from the nearest road and accessible

only by a half-mile-long footpath that ran up the bluff. If she had any relatives, she didn't tell neighbors about them.

Martin spent years amazing people on the trapeze, but once she settled down on the farm, she astounded the locals in an entirely different way. She wore men's clothing, and although petite and weighing only ninety pounds, her acrobatic musculature permitted her to do heavy farm work. Her mouth was a veritable profanity mill and the source of shame to many a man who *thought* he knew how to curse; hers was the sort of salty language that only long years of experience in show business can confer. This rhetorical ability was not appreciated by her hired help, who had to bear the brunt of it when Martin upbraided them for perceived sloth or ineptitude.

Although Martin had earned $400 per week at a time when the average American's salary was $750 per year, she lived in Dickensian squalor. The front rooms of her miserable house were choked with debris, broken furniture, bags of powdered cement and barbed wire. One room was used as a chicken roost. An upstairs room held a brand-new comfortable bed that had never been slept in—it had the original wrapping and an unused mattress. She slumbered instead on an iron cot. Some considered Martin eccentric, but she explained that she intended to remodel her house someday and saw no need to fix the place up in the meantime. In any case, the neighbors all agreed that the former circus queen was a good farmer.

During the last week of January 1934, Frank Sandage Jr., son of a tenant farmer, twice went to Alice Martin's home to deliver groceries and mail. She was nowhere to be seen either time. Her farmhand Ernest Wright, age thirty-two, told the boy that she had taken a trip to Plainfield, New Jersey. The police thought this explanation reeked of fish. They contacted officials in Plainfield who informed them that wherever Martin was, she was not there.

Suspicions about Wright increased when he also disappeared after police commenced searching Martin's beloved farm. On February 3, the former aerialist's body was found in a shallow grave—covered, perhaps symbolically, with manure—near the barn. She had a fractured skull and a slit throat and had been dead a week. She was dressed in her usual masculine attire, an enchanting ensemble consisting of boots and two pairs of overalls, a shirt, a vest and a jacket. She shared her homemade grave with two blood-soaked gunnysacks. An inspection of her hovel turned up only sixteen dollars and a notable dearth of feminine clothing.

Sheriff Anton Voges noticed bloodstains on a block of wood behind the house. Someone had unsuccessfully tried to burn other bloodstains on the ground. Investigators found evidence that the murderer had intended to

burn the house down, presumably with Martin's body inside, but then gave up and buried her. A freshly chopped hole in the floor, with a hatchet nearby, suggested that the killer thought Martin had hidden money in the house and searched for it.

It was no secret around Derby and nearby Tell City that Wright got along with his employer about as amicably as a tarantula and a pregnant wasp in a nature documentary; she was on his case constantly for neglecting chores. This animosity, plus the timing of Wright's disappearance, made him the prime suspect.

A three-state manhunt for Wright ended "not with a bang but a whimper," as T.S. Eliot would have said had he written true crime stories instead of squandering his talent on poetry. The suspect sheepishly surrendered at Cannelton on February 5. Since Sheriff Voges happened not to be at the jail at the time, his cute young daughter Julietta took custody of Wright and locked him up. In addition, a couple hundred people came to the jail when word got out that Wright had been arrested—not to lynch, but merely to gawk. Unwilling to take chances, Sheriff Voges had his prisoner transported to Evansville.

The authorities were deeply interested in knowing, among other things, how it came to pass that Wright had Alice Martin's feed and livestock in his possession when he surrendered. This is the story he told them with a straight face. Had it been set to music, it could have made a comic opera:

The farmhand did not kill Alice Martin, he claimed, but he witnessed the murder. Two weeks before Martin's death, a stranger moved into the cottage—Wright couldn't seem to remember his name despite having shared quarters with him for a fortnight, but he thought the man's name was Jack. This Jack fellow, or whatever his name was, must have been Alice's lover because he helped with the chores and she called him "honey" and "sweetheart." On the night of January 25, Alice and Jack had a Homeric quarrel that ended with her braining and slashing, after which, Jack forced Ernest at gunpoint to bury his boss and spread manure on her grave. The dastard swore he would return soon and claim Alice's valuable farm as his own, since he had tricked her into signing a phony marriage certificate. Then, Jack fled for Louisville, leaving Ernest Wright behind as a living witness to the murder. Realizing that he looked suspicious, Wright himself abandoned the farm—which of course didn't seem suspicious at all. But, drat the luck, while on the lam he met *another* crazy man with a gun who forced Wright to accompany him to Tobinsport, where they stole a boat and rowed over to Kentucky. And whom should Wright and his abductor

meet there? The mysterious Jack! The villains blindfolded Wright, put him in a car and released him at Cloverport, Kentucky. The fugitive hotfooted it back to Indiana; in Evansville, he found a wallet containing twenty-four fifty-dollar bills, with which he bought the feed and livestock on Alice Martin's farm. After this big adventure, Wright saw the error of flight and turned himself in at Cannelton.

The Evansville police believed Wright's yarn about as much as you do, and they interrogated him in such fashion as would give a modern civil libertarian a coronary. They denied him sleep and food and subjected him to constant questioning. They also told him that his fingerprints were on the club used to bash in Alice Martin's head. It was a lie, but Wright fell for it and confessed. This time around he told what *really* happened: Martin had remonstrated to him in her sweet and ladylike way after he lost some tools and broke a wagon. For this, she deducted $2.75 from his wages. She snapped, "I'll see you in hell before I will pay you!" In a drunken rage, Wright decided that she must die for her temerity and unfairness.

Wright went on trial in March. Judge Oscar Minor, while deploring the Evansville police's strong-arm methods of gaining the confession, ruled that it could be admitted as evidence since the prisoner's constitutional rights had not been violated.

The jury brought in its verdict on March 23: Wright was guilty of first-degree murder. On March 29, he was sentenced to life in prison. Wright faced the court's judgment with more equanimity than he had shown Alice Martin, former queen of the air, when she insulted him for his incompetence.

4

Mr. Wade and Mrs. Brown Hatch
a Stupid Plot

Mary Brown and Joe Wade were in love. They were also married—but not to each other, and that's where the trouble began. Was there any way the star-crossed lovers could be together? They thought and thought about the problem and decided there was a way: Joe would divorce his wife and then help Mary murder her husband, and nobody would put two and two together. Perhaps they should have thought a little harder.

Mary's husband was nearly twenty years older than she. He was John G.F. Brown, an evil carpenter (and how many evil carpenters could there have been throughout history?). They had married on August 25, 1867, when she was twenty and he was thirty-nine. They lived on a farm one mile south of Irvington, then a rural area on the outskirts of Indianapolis. Over the next thirteen years, they had three children and plenty of near misses with the law. To hear the neighbors tell it, Mr. and Mrs. Brown were united in both matrimony and murder. Persons to whom the Browns were indebted had a habit of disappearing. Mr. Hunter, a young German who lived in Seymour, had worked for Brown in 1875. A year later, he was last seen in the company of Mr. Brown, who owed Hunter back wages. Soon afterward, neighbors noticed Brown filling in a large hole in his garden, but nobody at the time made the connection between the disappearance and the digging. Ben Fletcher, half brother of Mary Brown, later reported seeing Hunter's jewelry in the Brown residence.

Next on the list of the vanished was a nameless old man who started boarding with the Browns after the German's disappearance. His host

borrowed $50. The old man was never seen again, but neighbors did observe Mr. Brown filling in another hole in his garden. Soon after this suspicious incident, Brown borrowed $300 from a physician; he was tardy in repaying it, so the doctor made a nonmedical house call. This was unwise. Later, when a farmhand reported seeing a mound resembling a grave in some nearby woods, Brown covered the spot with heavy rails. He had planted acorns there, he explained, and he placed the rails there to prevent hogs from rooting them up. It seems that the rails would also prevent the acorns from sprouting, but nobody asked questions.

In 1878, Dr. Levi Ritter found an unconscious man with a crushed skull lying on the road in proximity to the Brown farmhouse. Ritter took the man to the City Hospital in Indianapolis, but the injured man died two days later without naming his attacker. In addition to these mysterious occurrences, neighbors pondered the whereabouts of a boy adopted by the Browns. He, too, had disappeared one day and was never seen again.

Perhaps gossipers exaggerated or even invented the couple's many dubious achievements, but one fact is clear: the Browns' neighbors feared them. By fair means or foul, Brown eventually was prosperous enough to own several pieces of property in Indianapolis. Whether or not the Browns were killers, they certainly kept bad company. Their house was used as headquarters by a gang of thieves. At last, the Browns were arrested, not for murder, but for possessing stolen goods. Both husband and wife and a number of accomplices were convicted. Mrs. Brown appears to have served little if any time, but Mr. Brown was sentenced to a year in Northern Prison on January 9, 1879.

While Brown was in prison, his wife became enamored of Joe Wade, a local saloonkeeper whom she had met on July 2, 1879. Almost as soon as she met Wade, she asked him to move in with her on the grounds that she had been robbed recently and was afraid to stay alone. He found the suggestion agreeable and, within two months, had moved in permanently, having sold his "notoriously bad" Virginia Avenue saloon and divorced his wife. The happy man took on all the connubial duties of Mrs. Brown's absent husband, including tending to the livestock, chopping firewood and digging potatoes. I suppose Mrs. Brown specified which areas to avoid in the garden. She declared later under oath that she paid him for all this hard labor only with free clothing.

After the passing of several months, one problem affected the lovers' paradise: Mr. Brown was due to be released from prison soon and would be coming home. Wade suggested that they flee the state, but Mrs. Brown said she could not bear to leave her children. Wade gallantly offered to "steal them" from Mr. Brown. The situation was at an impasse when Joseph Brown

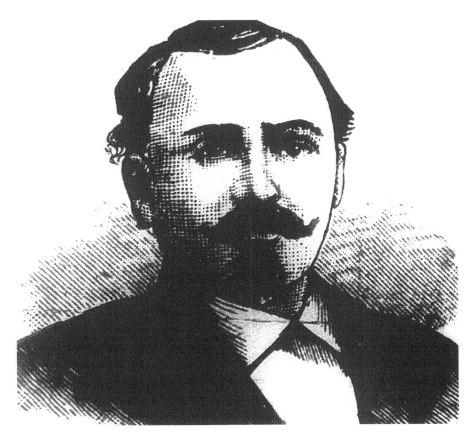

Joseph Wade. *From the* National Police Gazette, *March 6, 1880.*

left jail and returned to Irvington on New Year's Eve 1879. Little did Brown realize that his wife and Joe Wade were plotting his removal.

Upon Mr. Brown's return, Wade did not flee the house but instead remained as a boarder. The husband took his set of carpenter's tools and got to work making repairs around the farm. Wade became jealous and threatened Mrs. Brown, saying he would kill her and her husband—or so said Mrs. Brown, who later stated in court that she warned her husband of the threats.

On the evening of February 6, 1880, the entire family and Wade ate at the dinner table. After the meal, the two eldest children left to visit a neighbor named Smith. Wade asked Mr. Brown if he could borrow his buggy on the pretext that a Dr. Long in Irvington wanted to buy his (Wade's) horse. Brown

cheerfully agreed, though he asked Wade why it was necessary to take a buggy when he could ride horseback.

When on trial later, Mrs. Brown claimed she took no part in what happened next. As she cleaned the dishes, she said, her husband stood at the table whittling an axe handle. Glancing out the window, she saw the horse hitched to the gate, so she knew Wade had not left on his alleged errand. She took the remaining child, a baby, as she went to perform some chore outside. She heard a loud thumping noise coming from inside the house at the front door. Walking around the house, she saw her paramour standing between the house and the gate and her husband lying next to the buggy, his head covered with a blanket and his body on a red robe. The inference was that Wade had coaxed Brown to the front door, bludgeoned him with some object and then used the robe to drag his body out to the buggy.

When Mrs. Brown approached, Wade said curtly, "Take that child back in the house." She did so and then came back. She distinctly heard her husband groaning. As she told it, Mrs. Brown asked, "Joe, what have you done?" Like a villain in a stage melodrama, he embraced her and said, "This is what love will do, darling. I love every hair on your head better than my life!" She claimed that she wanted to take Mr. Brown into the house, but Wade retorted, "No, this work must be finished now." Wade placed the fatally injured Brown in the buggy, said he was going to dump the body somewhere up the road and ordered Mrs. Brown to clean up any visible bloodstains. When he returned an hour later, they hurried to the house of their neighbor Smith in order to establish an alibi. Wade knew well that he would be suspect number one when Mr. Brown's corpse was discovered, but he thought the Smiths' testimony would keep him out of prison.

Mrs. Brown claimed that the next morning, she and Wade went to visit Smith again, the baby and a fiddle in tow. Wade promised he would make a good father for her children and cautioned her to act nonchalant before the Smiths. He also instructed her to tell the Smiths that her husband had gone to Indianapolis to buy a stove. That night she saw Wade burn a mallet, which he acknowledged was the murder weapon. The two then had some interesting experiences removing bloodstains from an area near the front gate, from the front doorstep and from the carpet. A couple days after the murder, Mrs. Brown went to Indianapolis, pretending to be searching for her lamented husband whom she feared had been robbed and murdered, for he had unaccountably disappeared with a large amount of money.

Mr. Brown's body was found not in Indianapolis, of course, but by a railroad crossing on Belt Road back home. Brown's head was crushed,

and his buggy was nearby, still attached to his patient horse. Wade made disastrous yet darkly comical mistakes when arranging the crime scene. The buggy and the robes within were blood-spattered, yet the horse and outside of the buggy were unharmed; this would have been possible only if Brown had stepped out of his buggy, got hit by a train, climbed back inside the buggy, bled all over it, then climbed out again and expired beside the track.

Also, Wade had turned Brown's pockets inside out in order to suggest he had been the victim of a robbery, and then apparently changed his mind and decided to make it look as though Brown had been hit by a train. But he forgot to restore Brown's pockets to their original condition. Since trains seldom run over people and then rob them, authorities were suspicious. Conceivably, the train had run over Brown and some greedy passerby had plundered the corpse, but murder was the more likely possibility given local rumors about the closeness between Joe Wade and Mrs. Brown. The grieving widow was called to testify before the coroner; she told the story as Wade had coached her. But then she voluntarily testified a second time and confessed the truth. Her lover had started extorting her for money, and she realized their relationship might not work out. To put it kindly, not everyone was convinced Mrs. Brown was as guiltless as she maintained. It was largely suspected that she wanted to marry Joe Wade and inherit her late husband's money and property.

Joe Wade was arrested and sent to the Marion County jail. As if to prove that life imitates cartoons, Mrs. Brown slipped her lover some saws and a file to help make his escape. Wade was caught with the contraband and betrayed Mrs. Brown's confidence by admitting that she had given him the tools. In short order, the self-made widow was also jailed. She testified at Wade's murder trial on April 22, 1880. She spoke in such a low tone that the jurymen could barely hear her, and they sat only three feet from the witness stand. Perhaps incomprehensibility was part of her strategy.

The usual labyrinth of contradictory testimony ensued at the trial: a number of neighbors testified that her reputation for truth and veracity was very poor, but cross-examination suggested that many of the negative comments were based on hearsay. On the other hand, Wade had a reputation for being peaceable but had been known to be violent when manhandling rowdies in his saloon. Several incriminating letters allegedly written by Wade to Mrs. Brown were proved to be forgeries at the trial. Despite this evidence in his favor, the *Louisville Courier-Journal*'s Indianapolis correspondent wrote: "[I]t is the universal opinion that while Wade is not as guilty as Mrs. Brown, yet he will hang. And if Wade receives the death sentence, Mrs. Brown will also, and the two miserable

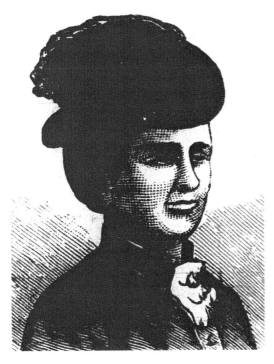

Mary Brown. *From the* National Police Gazette, *March 6, 1880.*

wretches will swing from the same scaffold."

The journalist rightly stated that things were looking dark for Wade. His attorneys claimed that he was an accessory after the fact—that is, they claimed Mrs. Brown planned and committed the murder of her husband, and Wade was guilty only of concealing evidence afterward. Few believed it, and Wade's only hope for a life sentence lay in a rumor that one member of the jury was opposed to capital punishment. His hope was dashed when the jury rendered its verdict on April 30: the sole juror who held out for life imprisonment was persuaded to vote for the death penalty. Wade remarked that the verdict was about what he expected; he still insisted that Mrs. Brown had murdered her husband and that he had only tried to shield her. He philosophically observed that in any case, he was a marked man, since no jury would believe that Mrs. Brown had committed the crime all by herself.

Mrs. Brown expressed delight with Wade's death sentence; truly, the bloom was off the romance. She claimed that Wade got what was coming to him since he "parted her from her children and murdered her husband." These sentiments were the direct opposite of those expressed in love letters she had written to him just after the murder. (Mrs. Brown claimed she could not have written the letters, as she was illiterate, but during her trial, the state brought out several witnesses proving the contrary.)

Mrs. Brown went to trial in early July 1880. She had testified against Wade at his trial, and now he testified against her. As he told it, she had become infuriated when, on the night of Mr. Brown's murder, he told her their affair was over and he intended to move to Michigan. Later that night, he said, he saw Mrs. Brown fatally strike her husband on the head with a mallet as he

stood at the kitchen table, whittling an axe handle. Horrified, Wade bolted from the house, but Mrs. Brown managed to catch up with him at the front gate while simultaneously dragging her husband's corpse. Improbable, yes, but the story got even better. Wade testified that despite having just witnessed a grotesque murder, he was still intent on riding to Irvington to sell his horse. He prepared to take Mr. Brown's buggy since his late host had given his permission, and besides, he was dead now anyway and would not care. Mrs. Brown, she of the Amazonian strength, cried: "Joe Wade, if you leave me you'll rue the day. You're a man, and I'm a woman; you've been staying here, and nobody will suspect me of doing this." Seeing the wisdom in her words, Wade forgot about his errand and helped his sweetheart wrap robes around the corpse and load it into the buggy. They drove away, Mrs. Brown at the reins; she had cleverly put on some of Wade's clothes so that if they were spotted, eyewitnesses would think she was a man. The pair dropped the body at the train tracks, and on returning home, they cleaned up the murder site and swore each other to secrecy. Then, they visited their neighbors, the Smiths, in order to establish an alibi. It was Mrs. Brown who burned the evil mallet, Wade insisted. After testifying, Wade said to a reporter from the *Indianapolis News*: "The only thing I have to regret is that I ever allowed that woman to get the hold on me she did. I tell you she is terrible."

Thus the jury at Mrs. Brown's trial heard a story almost diametrically opposed to one she had told at Wade's trial. The conclusion could be drawn, and was, that the two were equally guilty and trying to shift the blame on each other. The trial closed on July 10; the jury retired after hearing strong arguments from the prosecution and defense and after receiving careful instructions from the judge "defining the distinction between the several grades of homicide and the punishment prescribed."

Two days later, the jury announced its decision: Mrs. Brown was guilty and should hang, contrary to the widespread belief that the jury would never recommend that a woman be executed. Mrs. Brown, who had expected a life sentence at worst, was "paralyzed with horror." Ten minutes after the verdict was read, she said to a reporter: "My poor children! They will be disgraced forever." ("Why didn't she remember them when she killed their father?" demanded Wade.) Then she begged the reporter to ask Joe Wade "to tell the truth and not let me die." The journalist obligingly went to Wade's cell, but the prisoner displayed no concern for anyone but himself: "[I]f she had only been sent to the penitentiary, I would have gotten a new trial. But the jury couldn't do anything else. They couldn't hang me and let her live." After expressing a fanciful wish that the ghost of the late Mr. Brown could have

attended the trial and told what had really happened to shorten his days, Wade added: "Mrs. Brown can hang, as she deserves to. I believe in justice, though I have not been treated with justice."

As Joe Wade waited in prison for his execution date, he committed another crime by inflicting a couple awful poems on the public via the newspapers. The first, published by the *Indianapolis Herald*, laid the blame for the murder on the shoulders of his ex-girlfriend. Three verses will more than suffice:

> *and when She committed*
> *It was few words I could say*
> *She said if you leave me now my dear*
> *you will always rue the day.*
>
> *I never murdered John* [sic] *Brown*
> *or any man in my life*
> *I did not want his money*
> *Neither did I want his wife*
>
> *She is a murderess that I know*
> *as she told me this before*
> *She never Stuck in front she Said*
> *but the first lick killed him dead.*

Mrs. Brown's three children were adopted by her brother-in-law, who forbade them to visit her prison cell. The Brown property was purchased by a Mr. White, who reported that he received up to forty visitors per day, including some from such foreign places as Ohio, Illinois, Kentucky, Wisconsin and Michigan. They all thirsted to see the place where the famous Brown-Wade murder had occurred.

In September, Mary Brown and Joe Wade entered the courtroom once again, this time to receive their final sentencing: they were to be hanged from the same scaffold on October 27. "Awful," said the *Courier-Journal* in a headline, "But No More So Than Was the Horrible Murder of Old Man Brown." Both prisoners protested their innocence before being led back to jail. Mrs. Brown even swooned several times, as women in the nineteenth century were fully expected to do in stressful times.

Brown and Wade still had two chances to avoid the noose: the Indiana Supreme Court could decide to have them retried, and the governor

might show executive clemency. As of October 23, neither seemed to be forthcoming, and Sheriff Pressly of Indianapolis purchased new ropes and had the gallows overhauled in preparation for the big day. The *Indianapolis People* remarked, "We can hardly bring our minds to believe that Mrs. Brown will ever be hung [*sic*], and yet cannot see how Wade can well be hung [*sic*] unless Mrs. Brown is also. The public will hardly consent that one shall be taken and the other left, and yet the hanging of a woman is repugnant to everyone."

The set date for the hangings came and went—but there were no hangings. It was reported on October 28 that Joe Wade had converted to Catholicism. Governor James D. Williams died on November 20, and his last official act had been to sign a respite for Wade. The Supreme Court of Indiana granted Mary Brown a new trial, to begin in December. It took three and a half days to select a jury, a length of time "entirely unparalleled in the annals of jurisprudence in Marion County." On December 29, Joe Wade again testified against Mrs. Brown. On January 10, 1881, she was sentenced to life in prison. Several years later, she broke out of jail but voluntarily returned the same day. I have been unable to determine whether she fully served her life sentence.

While Mrs. Brown endured her second trial, a movement started to spare Wade's life. He was granted a hearing in the Supreme Court of Indiana in February 1881, pled guilty and had his sentence commuted to life imprisonment. The verdict appears to have been unpopular; the *Indianapolis News* remarked, "The Supreme Court, instead of using its powers to enforce the plain purpose of the law, has systematically used them to divert it."

For the next fourteen years, Wade languished in jail. In March 1895, Governor Claude Matthews granted a pardon due to the prisoner's poor health. The formerly robust bartender stepped out of the prison, coughing and wheezing, in the valley of the shadow of death and undoubtedly "ruing the day," to use Mrs. Brown's phrase, that she first stepped into his saloon looking for a roommate.

5

A Hoosier Makes a Spectacle of
Himself in Cincinnati

Charles D. Evans, age fifty, did not get along with his wife, Ellen, age forty-two—no, not at all. That's what neighbors in Indianapolis said when their opinions on the matter became a topic of interest to the authorities. But that was in 1933, and the Evans' domestic warfare had started long before then.

Mr. Evans, a real estate salesman and contractor, lived with his wife at 1321 Congress Avenue. He was industrious and owned fourteen pieces of property; she operated a hand laundry in their basement. However, the Great Depression harmed his business interests and properties' values, and he took control of his wife's earnings. This did nothing to increase marital harmony. Neighbors often heard them arguing. Mrs. Evans believed her husband unfaithful and hired a detective to watch him. Apparently, her suspicions were confirmed, because she filed for divorce in February 1933, after thirty-two years of squabbling.

The couple separated, but by mid-March, they were living in their Congress Avenue residence again. The housemaid, Dorothy Hill, said they had a vociferous argument on March 16. When Hill came to work the next morning, Mrs. Evans wasn't there. Mr. Evans said his wife had left the house in a fit of pique in the middle of the night and had not yet returned.

On March 19, Mr. and Mrs. Evans were traveling through Cincinnati, Ohio, a city famous for its early founding by hog butchers. Mr. Evans had been born in the city and perhaps had decided to pay a social call on his mother, Alice Hervey, or his brother Ben Evans, both of whom lived in the suburb of Norwood—the former on Forest Avenue and the latter on Melrose

Avenue. He was destined not to visit either. Mrs. Evans was making the trip in uncharacteristic silence. Mr. Evans undoubtedly was fuming; he carried a letter from an attorney advising him to pay his wife fifty dollars in monthly alimony.

Evans drove south on Hamilton Avenue and slowed down as he approached floodwaters crossing the road. A sharp-eyed motorcycle police officer, Elmer Joyce, noticed that his sedan bore an expired license plate reading "Indiana 1932." Joyce ordered Evans to pull over at the east end of the Ludlow Avenue viaduct.

"What about those tags?" asked Officer Joyce.

"Oh, I have until April 1 to get new ones."

"In whose name is the car registered?"

"My wife's."

Yet Mrs. Evans was nowhere to be seen.

The policeman noticed that Evans seemed excessively nervous; also, that a tarpaulin was covering something in the back seat. This suggested he was guilty of something more than a mundane violation. "A possible bootlegger!" thought Officer Joyce, who detained Evans while two other policemen, Joseph Cole and Major "Tip" O'Neil, arrived on the scene.

"What have you got in the back of your machine?" asked Joyce.

"Household goods."

The policemen removed the tarp, revealing a wash boiler, cooking utensils, kitchen pots and baskets. Joyce lifted the lid off one of the pots, expecting to find liquor. Instead it contained something cold, pink and fleshy.

"What is this?" he asked.

"A ham," said Evans. "I killed a hog."

"Where is your wife?" asked Joyce as a terrible possibility entered his mind—for he had noticed also that Evans's face was scratched.

"In Indianapolis," said Evans. Next thing the officers knew, he had removed a straight razor from his pocket and was cutting away at his own wrist and throat. Blood cascaded down his shirt and coat.

Evans was no lightweight at 235 pounds, plus he had a weapon. The police shot at his arm to stop his suicide attempt and missed. They tried manual force, but he was so powerfully built that he held off the three would-be rescuers with one arm while slashing his throat repeatedly with the other. Meanwhile, a deeply interested crowd gathered. They had come to see the flood but saw instead a death struggle between an armed giant of a man and the policemen.

Unable to stop Evans and afraid to get too close to him, the police moved to Plan B: they pleaded with him to kindly cease butchering himself in public. By this point, Evans had lost so much blood that the battle reached an impasse. He confessed that he had killed his wife, cut her into fourteen pieces, packed

them in cooking pots, loaded them in the auto and motored from Indianapolis to Cincinnati. "She tried to shoot me," he hoarsely explained.

He took $152 from his wallet and tried to hand it to the police, saying, "Give this to my mother." The officers told him that they refused to come any closer as long as he held the razor. He snarled, put the bills back in his pocket, sank the razor into his jugular vein and expired on the spot.

The body of Evans, and the fourteen parts comprising his wife, were delivered to the Cincinnati morgue. The upper section of her torso, one arm and one leg were in a copper-lined wash boiler lined with newspapers. The bushel baskets, also lined with paper, held Mrs. Evans's head, her lower torso and her other arm and leg. Two galvanized buckets contained her stomach. The officials at the coroner's department determined that she had been dead several hours and must have been murdered, dismembered, disemboweled and packaged at her home. Indianapolis detectives confirmed the theory when they checked the Evans's house and found flecks of dried blood on the white bathroom walls and cloth rags in the furnace that had failed to burn because they were saturated with blood. Also, a tarpaulin Evans was known to have used to cover a floor-sanding machine was missing. He must *really* have not wanted to shell out that fifty bucks a month for alimony.

The professional dissectors of the human body at the Cincinnati coroner's office expressed amazement at what an expert job Evans had done:

> *Each* [section was] *cut carefully at a point of articulation so that no bones had to be sawed or hacked through. The torso had been cut in two just below the ribs. The spine was severed also in a careful manner. Coroner M. Scott Kearns, Dr. J.M. Patterson, coroner's pathologist, and Dr. Edward Dulle…who examined the parts, declared they had never seen a more careful and complete job of dismembering at points of articulation. The legs, arms and neck had been cut through at the joints where a knife would do the work.*

Where Evans picked up such precise anatomical knowledge remains a mystery. So do his planned ultimate destination on the motor trip and how he intended to dispose of his wife's remains. The fact that he packed her in kitchen pots and baskets and brought utensils with him opens the imagination to some unpleasant, though colorful, possibilities.

The *Cincinnati Enquirer* paid the Hoosier salesman a dubious compliment by calling the spectacle he made of himself "a suicide which for gruesomeness surpasses anything in local annals since the slaying of Pearl Bryan in 1896." But that's another story for another book.

6
Hazel Triumphant!

Frank McNally of Hammond was a factory worker, age fifty-four. He was pleased when he married Hazel Hall, an attractive woman only twenty-six years old who looked even younger. Frank married Hazel for a reason other than her youth and attractiveness: more than anything else, he wanted to be a father. His fondest desire was fulfilled—twice over, in fact—when Hazel gave birth to twins, a son and a daughter, in December 1921.

Hazel was proud of the babies, too, and did all the expected things: she nursed them, rocked them, bathed them and took them for rides in a baby carriage. Like any happy father, Frank carried his twins around and doted over them. He never fed, bathed or changed them, but that was not unusual in 1921, when such activities were by and large considered "women's work." Anyway, Hazel insisted on doing these chores and refused help from anyone else.

Frank was slow to get suspicious, but after a while, he had to admit Hazel was behaving strangely. She was secretive when ladies came by to see the children and wanted to make a fuss over them. When company came, she invariably said the infants were asleep and could not be bothered. She kept the babies in the dark all the time, a circumstance that provoked much whispering among the neighbors.

One neighbor, Mrs. Agnes Sphirmer, became so doubtful that she spoke to Frank McNally in private. He agreed that he would let her sneak into the house and inspect the children next time Mrs. McNally was absent.

When the opportunity arose, Mrs. Sphirmer entered the twins' room and saw two small forms lying in bed. The cover was pulled back enough that

she could see the face of one: stiff, unblinking and expressionless. A wave of horror racked Mrs. Sphirmer's foundation. Were the babies dead? But closer inspection revealed the truth: they were not dead—they were china dolls with straw-stuffed bodies!

Frank's reaction when he found that the children of which he was so proud were actually toys can only be imagined. He remembered that a month after they were born, Hazel had taken them on a mysterious trip to Chicago. There was only one conclusion he could reach: she had murdered her own children and fiendishly replaced them with dolls, unaware that her husband was a match for her cleverness—or more so—and eventually would figure out her ruse.

So now it was October 1922, and Frank's pretty young wife was sitting in the Hammond courthouse on charges of having murdered her twins—charges brought by the grieving husband himself. During the trial, Hazel did not seem worried by the gravity of the charges against her; in fact, many observers thought she seemed to be having a pretty darned good time.

One witness, nurse Mary Griffith, testified that she had visited the McNallys two days after the twins were born. She noted that even then, Hazel would not allow anyone to touch them. Mrs. Griffith had not actually handled the babies, and she could not testify that they were human. She explained, "Mrs. McNally would not let me tend to the babies. I frequently saw her nurse them—at least she appeared to nurse them."

When Chief of Police Bunde testified, the truth came out. He stated that after Mr. McNally pressed murder charges against his wife, he had questioned Hazel, who told him that she never had actually given birth. She had faked pregnancy, faked childbirth, faked breast feeding, faked bathing the "babies," faked everything—all to hoax her miraculously gullible (to put it politely) husband.

Why did she do it? An operation she had had before she married Frank rendered her infertile, but she hated to disappoint her husband, who wanted children so badly. So she bought two dolls, pretended to give birth and fooled him good—for several months. The unanswered question: How long did Hazel think she would be able to get away with her scam?

If Frank McNally felt somewhat akin to an ass, he was not the only one. Mrs. Griffith, the nurse, was loath to admit she had been fooled. She was sure she had seen a spot of blood on one baby's cheek. When Griffith was asked under oath if she held any grudges against Mrs. McNally, this exchange entered the record:

"Well, it makes me mad to have her say she had dolls when I know she had twins."

"Makes you mad?"

"Well, to sit up there nine days with dolls makes me feel foolish."

"You mean it hurt your reputation as a nurse to say you nursed dolls?"

"Dolls don't bleed."

Dr. Cyrenus Campbell, who had attended Mrs. McNally during her fictitious pregnancy, was allowed not to testify when the defense objected that such testimony "would be violating professional secrets." The physician was likely quite relieved that he was excused from having to answer questions about how his patient had pulled the wool over his eyes most egregiously.

In the end, Judge Henry Cleveland ruled that no one proved there ever had been any real babies, let alone that Hazel had murdered them. She was acquitted on October 20, to thunderous applause of 150 female spectators and probably not a few ribald jests from the menfolk aimed at her clueless husband, who noticeably fidgeted after the verdict was pronounced, standing on one foot and then the other.

As spectators filed out of the courtroom, Frank McNally insisted that his wife actually had given birth to twins the previous December. Meanwhile, Hazel walked into the nearest department store and walked out triumphantly with her purchase: two enormous life-size dolls.

7

Pursued by a Monster

It is difficult to imagine a more alarming scene than that which confronted farmer William Starbuck when he returned to his house, located a half mile from Greensboro, on the night of July 9, 1904. He realized with mounting horror that his wife, Mollie, was nowhere to be seen—but she could be heard screaming in the forest. And where was their four-month-old baby, Beulah?

Starbuck ran in the direction of the noise and found his wife and child in an abandoned well one-eighth of a mile from their home. Mrs. Starbuck was hysterical and battered; the baby was dead.

The stricken man called in a doctor who could do but little. Mollie remained delirious and never regained enough lucidity to answer questions about her attacker. She shouted, "What are you doing here?" and "What are you going to do?" She did not recognize her husband and referred to being chased by a monster. At times, she raved so violently that she had to be restrained.

She died on July 11. At the inquest, the coroner noted bruising on her throat and the baby's as though they were choked. The baby had drowned while her mother died of "acute congestion of the lungs" caused by exposure to the cold well water and excessive screaming.

As mother and child were buried in the same grave, detectives got to work. They were baffled by the crime's senselessness: Mrs. Starbuck had been neither robbed nor sexually assaulted, and the murder of the infant was as pointless as any murder could be. In fact, they were not even certain the

Mrs. Starbuck. *From the* Louisville Courier-Journal, *July 24, 1904. Courtesy of the* Courier-Journal.

Starbucks *had* been murdered. Mollie was bruised and scratched, to be sure, but none of the injuries seemed sufficient enough to cause death. Could she have received her injuries by falling into the well? The house was not in disarray, nor were there any signs of disturbance outside, indicating that no struggle had taken place. A man who had passed by the house twenty minutes before Mr. Starbuck came home said all seemed calm and quiet. Bloodhounds were brought in and sniffed out nothing unusual.

These circumstances convinced some that Mrs. Starbuck, a new mother, had fallen victim to what we now call postpartum depression. Her physician, Dr. R.A. Smith, believed that after slaving over a hot stove all day and tending to the baby, Mollie Starbuck went insane and jumped into the well with her child—not with the intention of killing her, but to protect her from the monster Mollie thought was pursuing them. The doctor's hypothesis sounded convincing to the coroner, who ruled that the Starbucks' deaths were the tragic result of the mother's "puerperal insanity."

The theory, ingenious as it was, required one to believe that Mrs. Starbuck had throttled her baby (depressingly possible) and herself (not so easy), and by the end of July, few people could be found who believed it. Mr. Starbuck had ideas of his own. Some instinct told him that a twenty-one-year-old acquaintance named Haley Gipe was to blame, and he told the police so.

They summarily arrested Gipe and took him to the jail at New Castle. There he sang like a canary and, according to one account, narrowly avoided being the guest of honor at a lynching. He confessed that he was part of a three-man plot that went awry. The men heard that Mr. Starbuck sold some hogs and had hidden several hundred dollars. Their idea was to perform a home invasion and *scare* Mollie into handing over the money—but they did not intend to harm anyone. Gipe insisted that he had not actually broken into the house but had merely agreed to keep the plan secret. Another

conspirator, he said, was sixty-five-year-old William Lockridge. Gipe refused to name the third party.

By the end of August, three more men were arrested: Lewis Wales, Frank Wales and Joe George Lanham. The charges against them and Lockridge were eventually dropped. That left only one person to go to trial: Haley Gipe, who had only too obviously done his best to shift the blame onto anyone but himself. He was indicted by the grand jury in October; a *Courier-Journal* account includes the curious statement, "As yet he is ignorant of the serious charge that has been placed against him," which suggests that the papers knew more about the trouble Gipe was in than Gipe himself did. He found out the hard way on November 1, when he was arrested on a charge of first-degree murder.

Only a month later, on December 1, a jury convicted Gipe on the lesser charge of involuntary manslaughter rather than the original charge. It appears the members believed Gipe's story that he meant only to *scare* Mrs. Starbuck, not *kill* her. A popular speculation, which the jury may have heard, was that Gipe had so frightened Mrs. Starbuck by breaking into her house that she went insane and jumped down the well with her daughter, undoubtedly leaving him feeling foolish. His indeterminate sentence was two to twenty-one years in the State Reformatory at Jeffersonville. Under the circumstances, he got off lucky.

However, this was not good enough for Gipe. At the reformatory, he maintained his innocence and refused to work. After a round of punishment, Gipe straightened up and became a "good convict," an outcome that will not surprise anyone familiar with the concept of "discipline" as practiced in prisons of that era. Nevertheless, Gipe swore he'd take his case to the Supreme Court of Indiana to get a new trial. He was so obnoxious about it that a newspaper called him "one of the most advertised men who ever wore stripes at the Indiana Reformatory." As a result of his efforts, some came to believe—as they always will—that an innocent man had been railroaded; in particular, many in Henry County believed he was the pawn of an unscrupulous detective from Ohio. His case was reopened in March 1905.

Gipe's retrial took place the following November. He might as well have not bothered. On December 18, the jury returned a second verdict of manslaughter and back he went to jail, where he had many years to reflect on the fact that he was the type of man who, at worst, would toss a young mother and baby down a well or, at best, would frighten them into taking the plunge.

8

Justice, Possibly

Fred and Caroline Buente were wealthy farmers who lived with their family six miles west of Evansville. They may have thought, as many people do, that raising their nine-year-old daughter, Lizzie, away from the big city would keep her from finding evil influences. But on Wednesday, May 12, 1897, evil influences found Lizzie.

On that date, Lizzie was looking after cattle in an oat field. Someone crept out of the forest, raped the girl and left her for dead. The *Evansville Courier* described her injuries in no uncertain detail:

> [H]*er head was split open and her brains were scattered over the leaves and grass. Her clothes were torn from her lower limbs and the abdomen badly mutilated…The back of the head was mashed almost to a pulp and the brains were oozing out. Her eyes and mouth were filled with mud…The child's lower limbs were horribly bruised and mutilated, the abdomen having been mutilated with a knife before the rapist accomplished his awful work.*

The weapon was never determined, but examiners thought it was a hoe.

Lizzie was found unconscious an hour later and died in the afternoon without regaining consciousness. With her died not only her own hopes and dreams but also those of her parents and friends and all the good her descendants might have done on earth.

The outraged community got to work immediately. Neighborhood farmers organized posses, including one consisting of three hundred

men; if we read between the lines of contemporary news reports, they brought along more rope than one would think necessary, despite a *Courier* editorial urging that no one resort to vigilantism. The county commissioners held a meeting and offered a reward for the killer's capture. Judge Mattison ordered Sheriff Charles Covert to import R.T. Carter's famous bloodhounds from Seymour.

The bloodhounds followed a scent to Mount Vernon but lost the trail there. Several "suspicious Negroes" were arrested and jailed at that town. When the dogs were allowed to sniff the prisoners, they were interested in the scent of one particular man, Elbert Standard of Princeton, Kentucky. Blood spots allegedly were detected on his clothing; the story was later proved false. He was hustled off to the jail at Evansville for safekeeping. Standard protested that he had done nothing worse than sleep in one of the Buente stables. Police noted that his shoeprints did not match those left at the crime scene.

On May 14, Standard seemed cleared when word came that the right man—a black man named John Spaulding—had been caught at Morganfield, Kentucky. Nevertheless, mobs expressed a heartfelt desire to get their hands on Standard, and when Sheriff Covert took a special train to Morganfield, he took Standard with him. This was much to the disappointment of about three thousand people who surrounded the county jail and broke down the gate, so great was their wish to have a word with Elbert Standard.

Rumor held that a mob intended to travel from Mount Vernon to Kentucky to deal with Spaulding before Indiana authorities could pick him up, but the Morganfield jail was strongly guarded and any would-be lynchers were discouraged. A "mob" of six men did materialize, but their actions were limited to walking from the train depot to the jail, seeing the armed guards and then returning sheepishly to the depot.

No explanation was forthcoming in the papers as to the fate of Elbert Standard.

By this point, most onlookers were convinced of Spaulding's innocence. A prominent Morganfield attorney, Honorable H.D. Allen, interviewed the prisoner and vowed to defend him. On May 20, the examining trial was held to determine whether Spalding should be extradited to Evansville. Twenty-five witnesses came from Indiana, including Lizzie Buente's parents. A half dozen of them swore they saw Spaulding walking to Mount Vernon from the direction of the murder site. But there was no proof of guilt, and the Kentucky court discharged Spaulding for insufficient evidence.

The authorities in Evansville were displeased with this verdict and vowed to rearrest Spaulding. They wired back to Indiana requesting a warrant charging him with murder. But it appears nothing more was done.

"It may be," said the *Courier* as far back as May 14, two days after the crime, "that the murderer may never have justice meted out to him, but it will be no fault of the authorities and the law abiding people of Vanderburgh County." Chief of Detectives Brennecke was convinced the child's attacker hopped a freight train after committing the crime and was possibly hundreds of miles away.

Acting on the assumption that Lizzie's killer must be black, the authorities and Lizzie's neighbors may have let the real murderer escape. The *Courier* noted on May 16:

There is no proof to justify the statement that Lizzie Buente was killed by a Negro, as the majority of people believe. Many of the neighbors of Mr. Buente believe that the stylishly dressed white man who was seen in the vicinity about 10 o'clock Wednesday morning committed the murder. What makes this theory seem reasonable is the fact that this man has not been seen since nor [have] his whereabouts been ascertained.

Fred Buente mentioned a creepy occurrence that took place on May 16, four days after his daughter's murder. He and his brother-in-law, Mr. Schnerr, were standing on the railroad tracks near the Buente farm when they saw a stranger approaching. Buente and Schnerr hid in the shade and watched the figure, who carried something under his arm. When the man arrived near the murder site, he stopped, hung his head and repeatedly said, "No, no, I must not do it." After this display, the man continued walking to Evansville. For some reason, Mr. Buente did not follow him, a decision he later regretted. Had the killer returned to the scene of the crime?

The murder of Lizzie Buente was forever unsolved and justice was not done. Or was it?

On September 18, 1897, Gus Walters, presumably white and described as "a young man of good family," was found guilty in Evansville of the attempted rape of a six-year-old girl named Frances Weinert on July 6. On September 28, he was sentenced to the Indiana Reformatory for a term of two to fourteen years. The city's correspondent remarked, perhaps naïvely and perhaps not, in the pages of the *Louisville Courier-Journal*:

It is a queer coincidence that only a few months ago, when this community was startled with the story of the assault and murder of Lizzie Buente, a little country girl, Gus Walters led a posse in a bloodhound chase for the villain who committed the crime. Only a few weeks later he was arrested for attempting a similar crime.

It is possible the Evansville authorities put away a budding young serial killer without knowing it. We know now, as the people of 1897 did not, that a common characteristic of such murderers is their innate need to participate in the hunt for themselves—just as perhaps Walters did after Lizzie Buente was killed.

9

The Honeymooners

James and Lillie May Mastison, an attractive young couple, were married on July 9, 1901—possibly under the encouragement of a shotgun, because only six months later, in January 1902, Lillie gave birth. Soon afterward, the newlyweds moved into the home of Lillie's father, William H. Proctor, at 1418 South Street, New Albany.

At 9:30 on the evening of Saturday, August 23, 1902, the noticeably unhappy couple got off a streetcar and was walking to Mr. Proctor's house. A nearby patrolman, Jacob Fess, heard seven shots ring out. Investigating, he found Mrs. Mastison crumpled on the ground, shot four times, including once through the heart, dead at only nineteen years old. Mr. Mastison was absent but returned a few minutes later; he said he had run to a telephone to call for help.

The lighting was poor in that section of the city, but three witnesses—a nurse named Mary Keene, Dr. Ritter and R.B. Frazee—were close enough to hear a woman cry, "For God's sake, don't kill me! I have a little baby to care for." A man answered, "I'll finish you now."

The pool of suspects was small—in fact, there was only one: Lillie's husband, James, a twenty-three-year-old painter. He told the police that an unknown man had shot at the couple, hitting him in the wrist and killing his wife. What's more, he had the superficial flesh wound to prove it. Patrolmen Jacob Fess and John Rhinehart did not believe Mastison and arrested him at the murder scene.

The more authorities investigated, the worse Mastison looked. Inquiries established that he and his wife had been "on the outs" with each other for a

Lillie Mastison. *From the* Louisville Courier-Journal, *August 27, 1902. Courtesy of the* Courier-Journal.

while and had undertaken a violent argument on the Thursday night before her death.

On the day of the shooting, the Mastisons were supposed to meet downtown. Instead, Lillie went to the business district to make a payment on furniture. James, not finding her at their meeting place, went home in a rage and got a pistol. In other words, he was armed and angry on the night of her death. He went back downtown to look for her, and by coincidence, they boarded the same streetcar. Henry Platt, the motorman, said the pair had been pointedly chilly toward each other all the way home—their mutual hostility was witnessed by every passenger. The bickering couple got off, and less than a minute later, seven shots were fired in the darkness.

Coroner Starr noted that Mrs. Mastison's shirtwaist bore powder burns, so whoever shot her must have been standing close by.

But how to account for that fact that no gun was found on the suspect, even though police were at Mrs. Mastison's side soon after the shooting? The weeds were high in the area, and it was possible Mastison had thrown it in the underbrush with a plan of retrieving and disposing of it later. He had not counted on help arriving so quickly, the New Albany police theorized, and had to think fast. Confirmation came the day after the crime when a patrolman found a recently fired pistol in a vacant lot near Mr. Proctor's house. The lot was located along the route Mastison had taken to get to the telephone from which he made his emergency call. The pistol fired .32-caliber bullets—the kind that killed Mrs. Mastison—so it appeared that Mr. Mastison's phantom gunman had flung the weapon down rather than sensibly taking it with him.

Of course, there was no phantom gunman. When Mr. Proctor saw the gun, he said it belonged to none other than his son-in-law, James Mastison; it was immediately identifiable by its white handle and a mark filed on the

barrel. Mastison could do little more than look glumly at his feet and protest that he had no *earthly* idea how some villain managed to get hold of his gun.

Despite all the circumstantial evidence, Mastison refused to admit his guilt.

On August 26, the coroner's jury convened. One witness, William Overton, said that he, Albert Drury and Everett O'Connor had been standing a block away from the murder site on the night in question when they, too, heard those seven shots. Shortly thereafter, a man Overton identified as James Mastison came walking up the opposite side of the street. When they asked what the commotion was about, Mastison replied, "Someone has shot a dog." The "dog" had emitted humanlike screams, which the three men heard along with the gunfire.

Lucretia Proctor, Lillie's mother, said that Mastison had dropped by the house for a few minutes about an hour before the murder was committed. He appeared to be in a jealous rage, and told his mother-in-law, "She has run off and I expect she has gone over to the river to a dance, and if I catch her on the dancing floor she will come off." In fact, said Mrs. Proctor, he had a vicious jealous streak and forbade his wife to so much as look at any other man. On several occasions, Mrs. Proctor had heard him threaten to take Lillie's life.

The most important witness was Hugh Thomas, who lived at 1307 South Street, mere feet from the murder site. He heard the shots, looked outside and saw a man firing at a woman on the ground. According to Thomas, she said, "Oh my, you have killed me." Her attacker replied, "Damn you, I have fixed you." (The dialogue as Thomas remembered it doesn't sound quite right to modern ears—it has a stilted, stagelike quality to it—but hey, it was 1902.)

The coroner ordered Mastison—the one and only logical suspect in New Albany, or on the face of the earth for that matter—be tried for murdering his wife. In the face of all this, he still asserted his innocence.

The X marks the place where James Mastison's revolver was found. *From the* Louisville Courier-Journal, *August 27, 1902. Courtesy of the* Courier-Journal.

The grand jury indicted Mastison on October 16. His attorneys asked for a change of venue to Jeffersonville—or was it, as some thought, merely a ploy to gain more time? The request was granted, and the trial was scheduled to begin on November 23; however, it was delayed until December 8 because one of the defense witnesses, Mary Mastison, the prisoner's mother, was ill.

The accused man's court-appointed attorneys were Charles Schindler, Joseph McKee and Harry Montgomery. At first, they claimed their client was an epileptic—they said he had an "epileptic eye," whatever that meant—but soon dropped this unpromising line of defense. Then, they attempted, none too subtly, to blame the victim. According to a November 30 *Louisville Courier-Journal* report:

> *After his marriage…he became insanely jealous of her. She was good-looking, sprightly and popular, and frequently, it was stated, associated*

with persons of not the best reputation. Stories of her indiscretions were brought to Mastison, who was greatly in love with her, and these stories aggravated his mental condition.

About the best anyone could say for Mastison was that the killing had been so foolishly executed that it must have been done in the heat of the moment, as no sensible human could premeditate a murder *that* stupidly. For example, to list just a couple circumstances, the murder occurred only moments after a number witnesses saw him and his wife, obviously angry with each other, getting off a streetcar together, and he killed her next to a residence where, for all he knew, any occupant who happened to be home could see him at work. But arguing for a reduced penalty due to lack of premeditation wasn't good enough for the defense attorneys—they had to dust off the oldest, lamest excuse in the history of jurisprudence and pray for the best: they claimed their client, James Mastison, had been insane on the night he shot his wife down like a dog.

Pleading not guilty by reason of insanity was a strategic mistake: all this time, Mastison had steadfastly been denying that he killed his wife. But pleading insanity was a tacit admission that he *had* pulled the trigger after all.

The more Mastison pondered his predicament, the more nervous he became. If the creaky insanity tactic did not impress the jury, he would certainly swing from the gallows like a Foucault pendulum. So on December 9, the second day of the trial, he decided the smartest course of action was to come clean. He confessed and entered a plea of guilty. He claimed his deed had been manslaughter rather than a coolly planned murder, which may well have been true considering his extreme incompetence. To a reporter, Mastison said:

Yes, I killed her. But I was not responsible. I was crazy—crazy on account of her treatment and her way of living. I tried to do the best I could by her, but she did not appreciate my kindness, and deceived me not only once, but every time she got a chance. Had she been true to me the trouble would never have happened. I loved her as long as I thought she was doing right, but when I found out she was betraying the vows she had taken, I began to hate her, and I became insane. There has been insanity in our family, and no wonder I could not stand what she did.

He went on to confirm the details that everyone had long before figured out. After slaying Lillie, he had tossed the gun in the high weeds but had

The X marks the place where Lillie Mastison's body was found. *From the* Louisville Courier-Journal, *August 27, 1902. Courtesy of the* Courier-Journal.

been unable to reclaim it as planned because he had been immediately clapped into a jail cell. He added that he didn't think he would be in prison all *that* long.

He was sentenced to life at the Indiana State Prison in Michigan City without further delay. If anything, he seemed only too eager to start his prison sentence. He said being alone in his Jeffersonville cell was no fun, and he wanted to go where he could have some company. He also said that he was glad he murdered his wife and should have exterminated her long before he did. One wonders if he had such coldblooded sentiments about his child. The reader will recall that Lillie Mastison's last words were, "For God's sake, don't kill me! I have a little baby to care for." At the time of her murder, her baby was almost eight months old. The child sickened and died five weeks after its mother's death.

Mastison was taken to his new, permanent residence on December 14, during appropriately depressing weather. The prisoner and his escort,

Jeffersonville sheriff Herman Rave, arrived in the midst of a raging sleet storm that had knocked out Michigan City's electricity. The two slipped on the city streets like fugitives from a Mack Sennett movie until they got to the prison door.

James Mastison put the state and its taxpayers through much unnecessary trouble and expense; he admitted his obvious guilt only when it would have been preposterous to deny it any further, and even then only to spare himself the indignity of a hanging; and he wasted everyone's time and insulted everyone's intelligence by pretending to be insane. By contrast, and for a refreshing change of pace, let's examine the actions of another Indiana wife-killer whose crime took place in Kokomo on October 7, 1909, only a few years after the Mastison murder.

On that date, William Robison shot his wife, Jennie, in a dry goods store after she said she wanted a divorce. When he was arrested a few minutes later he said, "I guess I am crazy."

Unlike many killers who feign insanity, Robison actually had a believable claim to inherited craziness. His father, David Robison, had attained unenviable fame in 1875 when he slashed the throats of his two daughters, attempted to murder his wife and took a shot at his son, William. (In fact, the grown-up William had a bullet scar in his cheek, a permanent reminder of the day his old man lost it.) The elder Robison capped his energetic performance by taking a fatal fall off a train while trying to escape.

William Robison inherited not only his father's penchant for murder but also his stubborn streak. Instead of making the legal system jump through hoops as James Mastison had done, Robison immediately pled guilty and refused to use the insanity defense. When told he was entitled to a lawyer, he said he didn't want one. Within twenty-four hours of his crime, he was given a life sentence at Michigan City—the same place Mastison was sent. One wonders if they spent their life sentences comparing notes on how to abuse—or not abuse—the judicial process.

With a Smile on Her Face

The first national headline about the crime was datelined December 1, 1930: "Shock of Attack Is Fatal to Girl." In those more demure times, one had to read between the lines to understand that the vague headline meant a young woman had died of injuries sustained during a rape. She was Arlene Draves, age eighteen, who had just graduated from Emerson High School in Gary. Five men were arrested who were barely older than she: Leon Stanford, age twenty-one; Paul Barton, age twenty-one; David Thompson, age unknown; Henry Shirk, age twenty-four; and Virgil Kirkland, age twenty.

Such a crime would be scandalous to any community, but two of the alleged attackers, Stanford and Kirkland, had been idolized as former football stars at Gary High School. Kirkland had been the team's halfback in 1929 when they won the state championship. According to one account, he was expelled from school—reason not given. He had since gone to work at a steel mill and was the steady boyfriend of the girl he was arrested for raping and killing. Kirkland and Draves were not officially engaged, but it was said that they planned to get married. One of Kirkland's high school friends, Mrs. Ethel Madera, claimed that the couple had gone so far as to drive to Valparaiso for a marriage license, but Arlene appears to have gotten cold feet and called it off.

The already sufficiently sordid story got worse as details leaked out. The five accused men and Draves had been participants at a "gin party"—illegal in itself, since these were Prohibition days. It was held at the home of Thompson, a married man, on the night of November 29.

Kirkland told the police in a written confession that Draves got drunk and passed out, so he carried her to the porch to revive her. While there, he raped her. Later that night, the five men loaded Draves into Paul Barton's car and went out for hamburgers. When Kirkland went inside to order the food, the four other men gang-raped Draves—apparently with his encouragement. Kirkland came back to the car and sat with her while his companions went in to eat. She died in the car in the early morning hours of November 30, as attested by a loiterer at the restaurant who heard Kirkland shout to his party pals, "My God, feel her pulse! I think she's dead!" The panicking drunks rushed her to Dr. R.O. Wharton, who declared that she had passed away. Kirkland and company fled the scene as fast as they could, while the doctor urged them to come back and take some responsibility.

The four other prisoners also confessed. The coroner's jury held that Arlene Draves had died of cerebral hemorrhage and shock and recommended that all five be charged with first-degree murder. It was decided that they would be tried separately, with Kirkland's trial to be held first.

It seemed cut and dried, at least until Virgil Kirkland's trial began in Valparaiso on February 23, 1931, with the prosecution and defense seeking twelve jury members that could pass muster with both sides. Delicate (and indelicate) questions would have to be answered. Were the defendants' confessions legitimate? Was only one of them guilty? Were all of them? None? If any of them killed her, was it intentional or accidental—murder or manslaughter? How had Arlene Draves actually died? Was any sexual activity that took place at the gin party consensual or forced? To get to the truth, many details of the last hours of Draves's short life would be revealed under oath—details that ranged from the tawdry to the downright gruesome. People who enjoyed sensational trials would batten to their heart's content, at least insofar as the nation's newspapers would allow them to. Some details were deemed unprintable and remain mysteries to this day. Portions of the more shocking testimony that did make it past the censors came from acquaintances of Kirkland's, who swore that he said he would "knock [the] hell out of Arlene" if she refused to give in to his sexual demands. He also said he would "spoil Arlene" so no other man would want her.

The trial got under way on February 26. So many spectators attended that Judge Grant Crumpacker had to move the trial to a larger courtroom for fear the floor would collapse. A number of detectives and doctors gave testimony detrimental to Kirkland. Lieutenant Paul Thixton told of his initial confession: "Kirkland denied attacking the girl. [Deputy Coroner Chester] Owens then told Kirkland about the blood and bruises on Arlene's

body. Kirkland sobbed on my shoulder and then confessed. He admitted that he and four other men had attacked Arlene during the night."

The police got signed confessions from Kirkland and the other men as well, but the defense objected to Kirkland's statement being entered as evidence on the grounds that it had been "obtained with the aid of police blackjacks and under police duress." They appear to have provided no proof of this serious charge.

After a delay, Judge Crumpacker ruled that the statement, in which Kirkland admitted molesting his girlfriend three times, was admissible—but only if references to rapes committed by the other four men were stricken, presumably because such inflammatory statements might jeopardize their chances of getting fair trials later.

The next day's testimony featured a detail that no novelist would dare include in fiction. The witness was Victoria Leonard, the waitress on duty when Arlene Draves's alleged attackers hauled her to a late-night hamburger stand. Leonard testified that Kirkland and two of the other accused men had bloody hands when they paid for their food.

Richard Sturtridge, former DePauw University athlete, admitted he had supplied the party with alcohol. The defense's theory was that Arlene Draves bled to death when she got intoxicated and fell down, striking her head, and Sturtridge supported their contention. He saw Kirkland and Draves sitting on the porch, and then, "I went inside and heard a loud crash. I rushed out to find Babe (Arlene) fainted on the floor [of the porch]. Virgil told me she had fallen off a chair, drunk. I helped him pick her up. She was making a sort of sobbing sound."

On the other hand, Dr. James Burcham, coroner's physician, stated that the "falling off a chair" theory was nonsense, as it did not explain the extent and location of Draves's injuries. During the previous day's testimony, he said she had died of two hemorrhages, "one of them of the brain." (The papers prudently did not mention the site of the other one.) He now elaborated that her death was caused by "a cerebral hemorrhage plus shock of repeated attacks."

On March 3, Dr. L.N. Harger of Indianapolis, who had examined Arlene's vital organs, surprised everyone by stating that he found evidence that the liquor had been poisoned—but not poisoned enough to kill her. This did not necessarily mean someone had tried to commit murder by spiking her drink; during Prohibition, bootleg alcohol was liable to be filled with dangerous additives and unwholesome ingredients, and the imbiber of such hooch took his life into his own hands. Later evidence indicated that the party liquor included wood alcohol.

Testimony about Arlene Draves's fatal injuries was so contradictory that the defense requested her body be disinterred and reexamined. The judge ruled in their favor. Caroline Draves, sister of the victim, stood up and asked, "Can you do that without permission from the family?" When Judge Crumpacker answered yes, she fainted.

A team of defense physicians, attorneys and reporters took a trip to the small Lutheran cemetery in the town of Reynolds on March 4 to unearth Arlene's gray plush coffin and bring the poor girl once more into the sunlight. Naturally, the graveyard was choked with spectators whose fondest hope was to see something suitably horrifying. The coffin was driven to a small-frame building where the examination was to take place. Gawkers hopped into their cars and followed the lead vehicle to the building in a morbid parade. And it appears, from a March 5 *Courier-Journal* article, that they were not forbidden from entering:

> *They crowded into the tiny room, the coffin was lifted to a table and Coroner W.L. Henry lifted the lid. Arlene's brother and sister stood quietly at the foot of the coffin. Charles Draves, her elderly father, sobbed just outside the room. The spectators started as they beheld the body of the girl, three months dead. The cheeks were rouged, the eyes closed and the mouth smiling.*

She was probably the only person in the room who was smiling. The assembled spectators had a good look; then, and only then, did the authorities shoo everyone away except four physicians—two for the state, two for the defense. Tissue samples were collected for shipment to expert medical examiners in Chicago, the coffin was resealed, and Arlene once again laid to rest beside the grave of her mother. Charles Draves muttered, "Why couldn't they have left my child in peace?"

When asked about the exhumation, the defense admitted that matters looked very ominous for Virgil Kirkland and had his former sweetheart dug up out of desperation to find evidence that would exonerate him. Meanwhile, the prosecution made no secret of the fact that it wanted to dust off the electric chair with the seat of Kirkland's pants.

The experts in Chicago hastily examined Arlene's viscera, and the trial continued on March 5. The result was another stalemate: two defense physicians, Dr. Joseph Springer and Dr. H.O. Seipel, testified that they found no evidence of rape and opined that she had died of a blow to the head. Springer's opinion was convincing; he was Chicago's former coroner's

physician and had performed twenty-five thousand postmortems in the course of his career. By contrast, the prosecution brought in Dr. George Bicknell, also of Chicago, who declared that bruises and discreetly unspecified "other injuries" were present on Draves's body at both autopsies.

A sensation developed on March 5 when the defense said Virgil Kirkland would take the stand the next day to discuss his relationship with Arlene Draves and describe what transpired at the notorious gin party. This he did, tearfully telling the court how he met and fell in love with Arlene. She had visited him in the hospital when he was recuperating from a football injury. That's where they had their first kiss. Yes, they had had sexual relations, but it was consensual. They were engaged, he said, and they would have married soon had the great tragedy not occurred at the gin party. Concerning that party, he said:

> *We drank straight alcohol and wine. Babe and I went to a davenport and embraced each other. We talked of love. Then we went out on the porch to a settee.* [At this point, the attorneys for both sides quarreled like fishwives, after which Kirkland was allowed to continue.] *Arlene was dazed-like. I didn't slap her. I told her I loved her. She said she felt dizzy. And then she fell to the floor. I was dazed. We picked her up.*

He did not strike his unconscious girlfriend, he said; he merely shook her because she was in a stupor. Instead of calling a doctor, Kirkland and his equally intoxicated friends went out for a bite to eat and took the injured girl with them. As for Arlene's having been raped—either by himself or others—he seemed to know nothing about it.

The state wrapped up its case on March 9. John Underwood argued that Kirkland was a "wolfish" cad determined to "despoil" his girlfriend one way or another. Some witnesses, including Richard Sturtridge, had noted that Arlene said she wanted to leave the party and go home; Underwood saw this as evidence that she knew what Kirkland's real motives were. On the other hand, defense attorney John Crumpacker argued that the state had proved neither murder nor rape. (Mr. Crumpacker, incidentally, was the son of the presiding judge. If anyone thought this was peculiar, and possibly a conflict of interest, it does not appear in the record.)

Some of the final testimony came from Dr. Erik Bukhofzer, assistant pathologist at the University of Illinois, who stated that he found tears in a tissue specimen from the dead girl. This was at odds with the defense pathologist, who said he saw no torn tissue. The jury could be forgiven if it

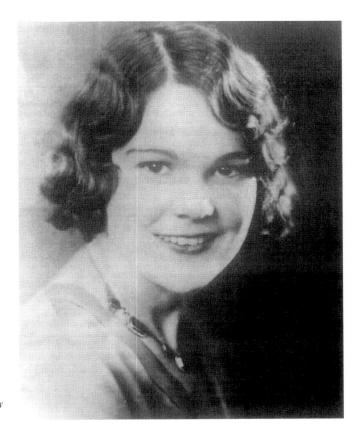

Arlene Draves. *Courtesy
of Thomas Clark.*

was badly confused by the mindboggling, contradictory evidence from the
dueling experts—and also by the fact that it was given twenty-two possible
verdicts from which to choose.

Despite the confusion, it did not take the jurors long to reach a verdict.
On March 10, after deliberating a little less than four hours, they found
Kirkland guilty of murder. The evidence showed, they felt, that Kirkland
had struck his girlfriend with his fist when she resisted his advances, causing
injuries that led to her death later that evening. They were not certain that
he had caused other fatal injuries by sexually assaulting her and did not take
that into consideration when deciding the verdict. The sentence was life in
prison at Michigan City. "We're satisfied," said Kirkland's attorney Barrett
O'Hara, which suggests that the defense team expected its client to go to the
electric chair. The next day, Mr. O'Hara preposterously opined that *society*
was really to blame for Arlene Draves's death—specifically, Prohibition: "He

wasn't the guilty one, remember. Society with its Prohibition, which brought about such gin parties, is really responsible for that murder."

On March 11, the day after the jury made its decision, the defense attorneys claimed that a mysterious woman had emerged with sensational new evidence that would totally clear Kirkland. The unnamed woman attended the gin party, they said, and had witnessed a girl who was jealous of Arlene Draves strike her over the head with a milk bottle. They did not say where this witness had been when the defense so badly needed her during the trial, nor why she had waited until the proceedings were over to come forward, but they implied that she would be of critical importance in winning Kirkland a reversal of his life sentence. This marvelous surprise witness must not have panned out, because we hear nothing more of her.

Nevertheless, Judge Crumpacker granted Virgil Kirkland a second trial in April 1931, scarcely more than a month after his first trial ended, on the grounds that "the evidence was insufficient to uphold the verdict." Crumpacker found fault with the jury's belief that Draves's murder had been premeditated; if that were so, asked the judge, why had Kirkland rushed her off to a doctor? (The judge's logic appears to be faulty in this regard. Kirkland and his pals sought medical help for Arlene only after they stopped off for a leisurely hamburger feast and finally noticed that she wasn't breathing. Also, when Dr. Wharton informed them the girl was dead, the men fled only to be caught later.)

Kirkland's second trial began on May 12 after the court had considerable trouble finding twelve jurors. The possibility that Kirkland had killed his girlfriend by punching her would not be considered this time around. According to the *Courier-Journal*, prosecutor Underwood amended "the indictments against him to include only two counts charging that Miss Draves was killed as the result of a criminal attack or attempted criminal attack." This meant that only two possible fates were now open for Kirkland: either he would be set free or he would go to the electric chair. He could not return to his life sentence.

The testimony was mostly a repeat of the first trial, but there were some new witnesses: George Regal and Edwin Minner, both Gary policemen, who testified that they witnessed Kirkland's confession after his arrest. Two Gary youths, John Churchill and Fred Phillips, testified that a few days before the gin party, they heard Kirkland say that he would beat up Draves if she didn't "accede to his demands." Nicholas Christoff, owner of the hamburger joint where Kirkland and his classy friends had stopped the night Draves died, said he overheard Kirkland remarking to them, "I fixed

her that time—now's your chance." This was understood to be an invitation to his friends to molest the unconscious girl in the car.

Two of Kirkland's friends at the gin party, Henry Shirk and Paul Barton, testified on May 18 even though they were awaiting their own trials; they spoke voluntarily and had not been promised clemency. The other two partiers, Dave Thompson and Leon Stanford, refused to speak on the grounds that they might incriminate themselves. Kirkland "seemed to cringe" when his pals took the stand, according to a reporter. As well he might have: much of what Shirk and Barton said was considered unprintable by the newspapers, but it is clear they admitted participating in a gang rape. The *Courier-Journal* reported:

> *Haltingly when their testimony touched upon the gruesome and the revolting, but without reservation, they admitted their own indiscretions at the party and accused Kirkland of leading the attacks which State physicians say caused the girl's death in an automobile shortly before dawn last November 30…*[Barton said,] *"She seemed to be unconscious. Kirkland invited us to be intimate with her."*

Shirk's testimony corroborated Barton's. It looked like Kirkland was bound for death row instead of freedom, and his attorneys promptly tried to find a way to gain a third option—that of sending him back to jail, for life if necessary and for less if possible. Judge Crumpacker seemed unwilling to give the death penalty to a man barely out of his teenage years, and on May 19, he said that he would grant a third choice for the jury. He would instruct them to reach one of three possible verdicts: guilty of murder by rape, guilty of rape or not guilty. If the jury chose the first option, Kirkland would die; if they chose the second, he would return to prison after all—and instead of his previous life sentence, he would serve between five and twenty-one years.

The jurors again were treated to the spectacle of respected doctors with excellent reputations and years of professional experience flatly contradicting each other. Dr. George Bicknell testified that Arlene Draves was killed by a blow to the head; Dr. E.S. Jones disagreed, and both physicians were *prosecution* witnesses. Dr. Harry Kahn for the defense thought Arlene Draves had died solely due to a cerebral hemorrhage, not due to injuries caused by rape. Doctors Dittner, Dobbins and Seipel agreed with him. But defense witness Dr. E.H. Powell rocked the boat when he complained about the nature of the questions Kirkland's attorneys asked:

That hypothetical question [asked by the defense about the hemorrhage] was phrased so it could be answered in only one way, and that's the reason I answered it that way. As a matter of fact, I believe that the criminal attack, exposure, and extrabural hemorrhage all contributed to the girl's death.

Kirkland himself took the stand again on May 21. "I couldn't have killed Babe," he said. "Why, we were engaged to be married. I loved her." He and Arlene had been sitting on the porch at Dave Thompson's house: "Then she got dizzy. I slapped her to sober her up." (Previously he said he merely shook her.) "She fell off a chair and hit her head on the floor." He admitted he and his cronies had abandoned the dead girl at Dr. Wharton's house but did not say why.

The case went to the jury on May 26. The jurors were given seven possible verdicts rather than the three choices Judge Crumpacker had said he would give when instructing them. They left the courtroom with the prosecutors' demand that they give Kirkland the death penalty ringing in their ears.

In a trial loaded with bizarre moments, one of the strangest came when the jury returned its verdict on the night of the twenty-sixth, after two hours' deliberation: Kirkland was guilty of assault and battery with intent to commit rape. The sentence that went with this offense was one to ten years in prison. This meant that, conceivably, he could serve only one year for good behavior. When the jurors discovered this after the fact, they protested that they did not realize the punishment would be so light. They thought the sentence would be death—they had fully intended to send Kirkland to the electric chair.

The situation was unprecedented. Judge Crumpacker confessed, "I am frankly puzzled. I do not know what to do." But after the sentence was passed, it was too late for a do-over. Virgil Kirkland, who was marked for the chair, escaped it only because of the jury's mistake.

The remainder of the squalid tale can be told in a few words.

Prosecutors threatened to demand that the proceedings be declared a mistrial but never did so. The jurors released a statement on June 7 to the effect that they had been confused because they were told at the beginning of the trial that the only two options for Kirkland were death or freedom but later the judge opened a third possibility. It was to no avail; assistant prosecutor Robert Estil told the press that Kirkland had officially been sentenced and the jury's statement had "no legal value."

On May 27, Kirkland was sent to the reformatory at Pendleton to serve his comparatively soft one- to ten-year sentence. Judge Crumpacker told

the prisoner as he left, "You have been fortunate." A prosecutor remarked, "Now when you get out, behave yourself."

The defense's victory was marred somewhat when Sheriff Birney Maxwell arrested one of Kirkland's attorneys, Ronald Oldham, on a charge of passing a bad check in Ohio. Oldham settled his bad debt, only to face a charge in early June of practicing law in Illinois without a license, which would cost him a $500 fine.

Another defense witness, one of the plethora of doctors called to the stand, was found drunk in the street after the verdict was rendered.

On June 9, Judge Crumpacker put an end to the case when he refused to alter the jury's verdict. The *Courier-Journal* related: "The Judge challenged the State to prove that Kirkland should have been given a longer sentence under a jury's verdict of 'guilty of assault and battery with intent to commit criminal assault.' The prosecution offered no evidence."

The other four men who were arrested along with Virgil Kirkland never went to trial even though two of them admitted *under oath* to being rapists. They were released from jail and slunk back to their everyday lives.

Virgil Kirkland sought a parole in June 1933 and was turned down. He tried again in August 1937 and got lucky. He was set free, having served six years and three months of a sentence that the jury thought far too lenient even if he had served every minute of it.

Arlene Draves rests yet in Reynolds with a smile on her face.

11

The Stage's Loss Was St. Louis's Gain

On March 1, 1914, Ada Owsley, formerly from Madison, Indiana, shot her husband, Benjamin, three times in their home at 1219 Warren Street, St. Louis. When the police arrived, they found Mr. Owsley dead on the floor and his wife in an attitude of prayer. She had contusions over the left eye and on her left cheek and leg, and there were signs of a recent struggle in the room. The self-made widow's tone was nothing short of boastful:

> *I have been able to shoot squirrels out of a tree with a revolver. My husband and I quarreled, and he insulted me grossly. He then started into another room, saying he was going after a revolver. I took a revolver out of a bureau drawer, and when he returned, I began shooting. He kept coming, and I fired until he dropped. I was surprised, as I am a crack shot and thought several of the shots must have hit him.*

Her story did not jibe with Mr. Owsley's condition. Although she said she shot as he approached her threateningly, the only bullet wound the dead man had was in his *back*, so he must have been walking away from her when she shot him. Also, she said at first that she fired "several" shots but later would claim she fired only twice. Later still, she would include the additional detail that he had brandished a poker, though she said nothing about the weapon in the earliest reports.

Officers took Mrs. Owsley away—not to jail, as one might expect, but to a hospital—so she could recuperate from the nervous condition that a

woman develops after ventilating her husband. At some point, the demure flower must have realized that her piratical braggadocio would not win an acquittal if her case came to trial. While in the observation ward, she made a show of hysterically crying out for her beloved Benjamin and asking the doctors about his condition, as if she were unaware that she had just put a hole in his hide.

Paradoxically, while on one hand she claimed that she thought Mr. Owsley still walked among the living, on the other hand, she wrote a confession in which she admitted killing him. She added that the shooting was in self-defense and the culmination of months of physical abuse. He had attempted to "force indignities upon her" and, in 1912, had vowed to kill her with a razor and a hatchet. At the hospital, she said, "I wouldn't have harmed a hair on his head, although he did abuse me. I loved him. I know I killed him, for the Lord stands before me and tells me. I must be a murderess, but I don't care if I am strung up. I will tell the truth."

It seems she was only feigning indifference as to whether she was "strung up." At the coroner's inquest on March 3, she shifted from the arrogance she had displayed after the shooting to a grossly overplayed fearfulness, as though she believed her husband was alive and expected him to give her a thrashing right there in the coroner's office.

"Have mercy on me!" she screamed as a patrolman led her into the room. "Have mercy on me! Where is he? Don't let him beat me anymore!"

Then, she sobbed bitterly—and ostentatiously—in the arms of her son by a previous marriage, Edward Ricketts.

The newspapers tell us that "[s]he became so frantic that the officers were directed to return her to the hospital as quickly as possible." Thus, she was spared from telling her story on the stand and facing cross-examination. Edward Ricketts filled in the gap by testifying that his stepfather "was abusive to his mother, would not speak to her for long periods, often threatened to kill her, and nagged her about other women." That last phrase meant that the cad loved to tell her how attractive other women found him.

However, her stepson, Robert Owsley, testified that he had heard her boast about her prowess with a pistol and that she said she had shot a woman in Madison in 1905. This interesting revelation appears to have never been further investigated.

The coroner's jury, possibly impressed by Mrs. Owsley's histrionics, found that she had killed her husband in self-defense. The *St. Louis Post-Dispatch* noted that five of the city's women in the last three years had murdered their spouses, and all five had been acquitted. (One of them, Alma James, claimed

she was asleep when she shot her dear Leon; another, Emily Roberts, could provide as a motive only that her William had boasted ceaselessly of his infidelities. The reader may be forgiven for supposing that while women could not vote in 1914, this infringement of their civil rights was somewhat palliated by the ease with which so many of them got away with murder.)

Mrs. Owsley was set free and spent another month in the hospital recovering from what was called "hysteria," one of those vague old medical terms that can mean nearly anything.

Despite the coroner's jury's ringing endorsement, Ada Owsley was not out of the woods yet, legally speaking; her stepson, Robert, agitated to have her tried, and the grand jury decreed that she be indicted on a charge of second-degree murder after all.

One of the state's witnesses in the second trial was Benjamin Owsley's former wife, Rosa, who said she would have some unflattering stories to tell about poor, put-upon Ada—not the least of which was that she was a home-wrecker who had seduced her Benjamin.

Ada Owsley's trial began on May 6. She entered the courtroom dramatically: she was dressed in black, heavily veiled and leaning on her natural son's, Edward Ricketts, arm. Her performance in this venue outstripped the comparatively restrained presentation she gave before the coroner's jury. Had she actually been an actress onstage, no doubt she would have employed the then popular—and famously unsubtle—Delsarte method, replete with gestures and gymnastics. During cross-examination, she shrieked and cried, "Bennie, I didn't want to shoot you! Oh Lord, have mercy on my soul!" The women in the courtroom wept.

She said she was a battered wife. Bennie choked her so often that she had to wear a handkerchief around her neck to hide the bruises. On one occasion, the brute ordered her to remove the handkerchief: "I made those marks!" she claimed he had said. "They are signs that I love you!"

This is what she said happened just before she shot him. The reader may believe as much of it as he likes:

> *He kicked me on the shins as I sat in the Morris chair in the front room after dinner, until I got down on my knees* [just like a Delsarte actress] *and begged him to stop. He tore off my glasses, saying, "I don't want to go to the penitentiary for hitting you with your glasses on."* [Yet he apparently didn't mind if she walked around in public with bruises on her throat, visible evidence he had choked her; and did he think he would not go to jail as long as her glasses were

off when he struck her?] *He jerked me onto the bed. I tried to get away, but he threw me back again. He knocked me down three times. "Where's that gun?" he demanded. I told him it was in a trunk in the front room. As he went into the room to search for it I heard him lock the front door. Then I drew the revolver from the washstand drawer beside the bed. He returned from his search and looking at my face, which was streaming with blood, said: "I've spoiled your face, kid, now I'll take the poker to you." As he reached down for the poker I fired. I don't know how often I fired. All I remember is hearing him shout and seeing him coming toward me with hands stretched out like this and his face looked all purple. Then he fell. I fired because I knew he would kill me.*

After this theatrical recitation, she swooned. She revived just in time to shout, "God have mercy on me!" as she was carried out of the room by two deputy sheriffs.

A patrolman named Rohlfing testified that Mrs. Owsley had admitted that she shot her husband in the back while he was running away, a flat contradiction of both her initial confession and the story she told under oath. While at the hospital, Mrs. Owsley displayed bruises and cuts she supposedly got before the shooting, but the city's autopsy physician testified that her husband's corpse had a bruised nose and a scratched finger, which infers that the couple had a brawl in which Mrs. Owsley gave as well as she got. Evidence regarding the couple's quarrels was not permitted, and former wife Rosa Owsley's intended testimony about Ada's bad reputation was dismissed as remote.

But none of that mattered; it was an era when all-male juries were reluctant to find any woman guilty of murder unless she confessed to a crime of unusual magnitude, such as poisoning a couple generations' worth of her family or burying a carload of murdered hobos in her cellar. Had there been some skeptical, nonsympathetic women on the jury, Mrs. Owsley might have found her path more difficult.

After deliberating for forty-four hours, the jury could not reach an agreement and was dismissed. The more rational among them pointed out that Mrs. Owsley's pathetic, mouse-like trembling in court did not square with the cool boasts about her excellent marksmanship just after she killed her husband.

Even had she been convicted of third-degree manslaughter, as some jurors wanted, she probably would have received the minimum penalty of three months in jail and a $100 fine. There is no record that Mrs. Owsley was tried a second time for the slaying.

12

Otto Embellishes

Otto Vest married twenty-three-year-old Lucille Tabor at Seelyville on September 7, 1917. It was her second venture onto the sea of matrimony; her first husband, a man named Bailey, and her two children from that marriage lived at Glen Ayr, a town of microscopic size near Terre Haute. Rumor held that Lucille married Otto without legally severing ties with Mr. Bailey, but we'll let that pass.

The newlyweds moved to Ninth and Jackson Streets in Columbus to start a life together. Instead, neighbors said they spent a considerable portion of their time quarreling. On October 29, after a few weeks of wedded bliss, Lucille informed Otto that she felt their marriage wasn't working out. She made her point by swallowing fifteen cents' worth of carbolic acid and expiring horribly thirty minutes later. That's the story Otto told the cops—the first story, anyway.

Otto was indignant when the police questioned him about his wife's suicide. He professed not to see anything strange about it. Yes, he admitted, he had purchased the poison. But it wasn't like he deceptively slipped it in her porridge. He openly gave it to her, and she *willingly* drank it.

Why on earth would you do that? Why on earth would *she* do that, asked the cops.

Well, mused Otto, she had often expressed the desire to kill herself. So, being a good husband and not a chauvinist who would prevent a woman from achieving her fondest goals, Otto bought the carbolic acid for her as a sort of present. He watched her quaff deeply of the drink of death—and

then he left the house. By the time he returned, she had already become a memory.

As he touchingly told the police, "If she was damn fool enough to take it I thought I would just buy it for her."

Even at this early stage in the investigation, Vest contradicted himself. He told some that his wife had requested that he buy the acid so she could use it as a disinfectant; to others, he said she wanted to kill herself with it and he obligingly procured it for her; to A.H. Fehring, the druggist who sold it to him, he claimed that he wanted to use it on a horse.

For some unaccountable reason, the authorities found Otto's story—that is, his *stories*—farfetched, and they arrested him, but on a charge of manslaughter, not murder. Some official must have believed Vest's claim that he handed his wife carbolic acid knowing that she intended to drink it, making him an accessory, not a murderer.

A third possibility was that Otto Vest was neither guilty of manslaughter nor an innocent dupe; perhaps he had induced his wife to drink the carbolic acid—making him a murderer. We will never know for sure.

The local paper, the *Evening Republican*, said in its October 30 edition, "This morning Vest began to realize the seriousness of the charge against him." Evidently, it took several hours for him to figure out that his wife's horrifying demise was no lighthearted frolic and might have distasteful legal ramifications. He asked the police if they would take him to the funeral home so that he might have a final glimpse of his poor Lucille. They obliged, and he spent a while gazing at her face and weeping.

Vest was offended by the very idea that he should be arrested and went on a hunger strike as soon as the cell door closed behind him. He asserted that he would soon join his dead wife; presumably, he was eager to quarrel with her again. Cynics thought he might have a less romantic motive for starving himself, i.e., a healthy fear of the electric chair. His strike lasted five days, until his appetite won out over love.

Vest was indicted on December 1 for first-degree murder, not the original charge of manslaughter, so someone in the legal system must have changed his mind about the possibility of Vest's innocence. When his trial began on December 19, the parents of his dead bride were among the interested spectators. From the beginning, Otto appeared to have an adversarial relationship with truth; he swore under oath that he was twenty-seven years old but later admitted he was thirty-two.

By now, Vest had changed his story—and not just in a few trivial details. His new version was a total makeover. No longer did he state that his wife

had repeatedly expressed the yen to commit suicide. Perhaps realizing that his first story made him seem unattractively coldblooded, he now claimed that yes, he had given his wife carbolic acid but only because she had used it for medicinal purposes before, so naturally he thought that was what she wanted it for this time, too. How was he to know she intended to down the entire bottle?

There were, in fact, a few medicinal uses for carbolic acid—it could be used as a home remedy for toothache, for instance. But it was up to the defense to prove that Mrs. Vest had used the drug for such purposes, and it appears they failed to do so. It shouldn't have been difficult because a prescription was needed to purchase something so dangerous, and there would have been records of Mrs. Vest's ailments among doctors and druggists.

The jury retired on December 20, but despite the unlikeliness of Vest's stories, it was unable to reach a verdict and was dismissed. The majority of jurors were for acquittal.

The case went to a second jury on February 5, 1918. In less than an hour, Vest was acquitted and free to go tell all the fishy stories he pleased. If he married a second time, his new bride likely poured any beverage he handed her in the cracks of the floorboards when he wasn't looking.

13

William Wants to Get Married

Twenty-two-year-old William Lee of Boonville had been in love with a luscious lovely named Mina Taylor for some time, and he planned to marry her on August 24, 1911. William spent that night in jail instead of in connubial bliss with his beloved Mina. And all merely because he pulverized the skulls of his father, Richard Lee; his mother, Sarah; and his younger brother, Clarence, and set the house on fire.

William refused to comment on the events of August 24, other than to explain that the house was already on fire when he awoke. He said he got up to rouse his family and sound the alarm—but had taken care to get fully dressed first (because who knows when one might meet ladies, and it would be a deplorable social faux pas to be caught in a nightgown). He theorized that someone else must have murdered his family, lit the fire and run.

The absurd story might have been believable except for a flaw in William's master plan: firemen extinguished the fire so quickly that a curiosity-seeker took a photograph of William with bystanders and the remains of his family lying under sheets.

Inside the house, investigators found a bloodstained axe and hatchet and kerosene-soaked furniture. The bodies' clothing was saturated with coal oil. What *wasn't* in the house was equally interesting: $100 in cash the Lees had gotten the day before by selling property. Witnesses told the coroner that William received his fair share of the proceeds but had argued with his father that he deserved more because of his impending nuptials. Also, neighbors said Lee's parents objected to his marrying Mina. (The young man was

Lee family portrait. William Lee is wearing the white shirt and leaning against the wall. The rest of the family is lying under sheets in the foreground. *From the* Louisville Courier-Journal, *August 26, 1911. Courtesy of the* Courier-Journal.

noted for his laziness and for being a drain on his parents' resources, so one would think they'd be happy that he wanted to leave the nest.)

William was taken to the morgue, where the crushed and toasted bodies of his family were dramatically unsheeted before his eyes. He displayed no emotion and merely lit his pipe. Back in her hometown of Newburg, Mina shrieked before reporters: "I know he is innocent!"

The suspect kept his composure until the next day, when he confessed. Yes, he said, he had killed his father, Richard, but only in self-defense—after Richard first killed his wife and other son. Then, said William, he committed arson because he was sure no one would believe the truth: "I could smell coal oil, and I found oil had already been poured over the bed. Just because matches were handy and I didn't know what else to do I set fire to the bed clothing and gave the alarm of fire." In other words, it just seemed like the thing to do.

Sheriff Raymond Scales took Lee to Evansville so he would not be lynched. Physicians disproved Lee's tall tale when they examined the bodies and found they had been dead at least three hours before he alerted neighbors to the fire. His bloody, scorched underwear was found hidden in the bedding.

In the face of such evidence, Mina turned her back on her former sweetheart and wished that he would be punished if proved guilty. She fainted at the Newburg cemetery when the three coffins of the Lees were lowered into an extra-wide grave. She probably also contemplated how close she came to marrying the type of man who would bludgeon and burn his relatives because he was peeved at them.

The silly stories he told convinced no one, so on August 26, Lee told the truth: he had butchered his folks out of anger because they disapproved

of his marriage and refused to give him money to finance it. In addition to that, his father and brother were insured for $700, and William was the beneficiary—that is, if his mother died before he did. Lee was sent to the Jeffersonville Reformatory, where he resided in the cell formerly occupied by Thomas Hoal, the Boy Bandit (see later chapter about his notorious career).

Earlier in the same day, Mina Taylor declared that she would marry William yet if he were innocent. His confession dashed her hopes. She cried, "Oh Will, why did you do it?" and collapsed in hysterics. Her father said she would live with relatives in Colorado until she recovered from the heartbreak.

At the reformatory, Lee made a third confession, which, like the others, failed to make sense in some particulars. He claimed he had been threatened with death by both parents. He was so certain they intended to kill him that he decided he would kill them first. (No explanation as to why he felt compelled to exterminate his brother.) He said he had not intended to burn the bodies—after applying the axe to his family, he lit a match to contemplate his handiwork and dropped it on the bed, hence the conflagration. (No explanation was given as to how the bodies were first saturated with coal oil.) He claimed additionally that he had been abused by Mr. Lee for years, which for all we know was true.

Mina said, "I will try to forget Willie as soon as possible. I hope time will heal the wounds caused by this terrible tragedy."

At the end of November, William was returned to Boonville on the grounds that potential lynch mobs had cooled down. "Yes, I killed them," the unsentimental fellow said of his family. "I feel justified because I thought they were going to kill me and because of the whippings they gave me when I was a boy." He added with ill-found optimism, "I expect to get two to twenty-one years for this."

Lee collected the life insurance on the family he murdered—it must have been a *very* generous company—and used the proceeds to pay his defense attorneys, brothers Caleb and Thomas Lindsey. He faced the Circuit Court on December 5. Surprisingly, despite his three confessions, William pled not guilty on grounds of self-defense. *Not* surprisingly, given how many other defendants in this book also tried it, his attorneys entered a plea of insanity as a backup plan.

Before going on trial, William Lee was moved again, this time to Evansville, where the proceedings would be held due to a change of venue. He was placed in what was called "the unlucky cell" because everyone who had occupied it had been convicted.

The trial began on January 24, 1912. As promised, the defense tried to prove Lee was insane, but its evidence for his hereditary "mental taint" was feeble. Rather than being content with one crazy parent, it boldly claimed both were unbalanced. The defense's star witness was Josephine Jones, who had lived with the Lee family for a decade. She thought father Richard Lee was insane because he "was of an eccentric turn of mind, and refused to believe the world was round, and looked upon the Bible as a fable, and always laughed when he read it because it was so much like a novel." Mrs. Jones believed Sarah Lee was crazy, too, because she had once "rejoiced over the death of her brother."

As for William Lee himself, the evidence for his mental illness largely consisted of his boasting to girls that he was wealthier than he actually was and that he cried a lot. Under oath, Lee recanted all of his confessions and now claimed that he had no idea who slaughtered his family. He polished the old, old chestnut of selective memory loss: he couldn't remember killing anyone, and the whole episode "seemed like a dream" to him.

When at the jail, however, the "crazy man" spent time cracking jokes with fellow prisoners. The prosecutor, Ora Davis, revealed that Lee promised to plead guilty in exchange for life imprisonment, indicating that he wasn't nearly as unbalanced as his attorneys wanted him to seem. Davis responded that he would settle for nothing less than the death penalty.

Countering this woeful evidence for Lee's insanity was Dr. C.E. Laughlin, superintendent of the Southern Indiana Hospital for the Insane, who answered a whopper of a four-thousand-word hypothetical question by saying that in his professional opinion, William Lee was sane.

Many observed that during cross-examination, Lee answered "I don't know" to any question that would incriminate him, but his memory was jim-dandy when he was grilled on less serious matters.

On January 31, the jury decided that Lee was perfectly sane and comprehensively guilty—yet it fixed his punishment only as life imprisonment. It was a relatively light punishment, considering the barbarity of his crime. A *Louisville Courier-Journal* editorial remarked, "Kentucky has no monopoly of chicken-hearted jurors…If any criminal in Indiana ever deserved the death penalty that criminal was Lee."

A week later, William Hester of Hopkinsville, Kentucky, went on trial in Evansville for murdering his girlfriend. According to a news account, "The State's Attorney…refused to ask the jurors in the Hester case if they believed in capital punishment, contending that it is impossible to hang a man in this Vanderburgh County."

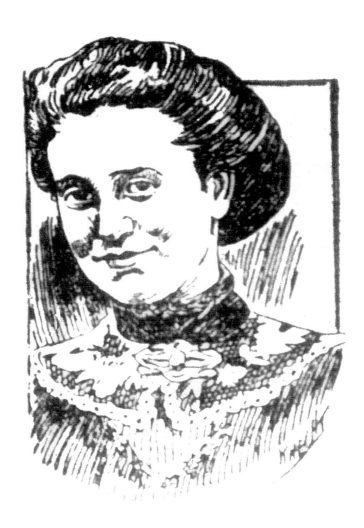

Mina Taylor.
William Lee was
willing to kill so he
could marry her.
From the Louisville
Courier-Journal,
August 29, 1911.
Courtesy of the
Courier-Journal.

Mina Taylor, for whose hand William Lee murdered three people, married a neighbor named Curran Keeler on June 24, 1913. William's thoughts on the matter are not recorded, but it musta hurt!

William had been in prison less than a year when, in November 1912, some Evansville citizens decided it would be a fine thing indeed if a man who killed his family for money were to be turned loose, and they started a petition to secure his parole; their tenderhearted—to say nothing of misguided—efforts were rebuffed. But no matter—William Lee's life sentence was destined to be a short one. He died in his cell in September 1914, age about twenty-five. Was it suicide or natural causes? Prison officials did not say. His relatives did

not wish to be burdened with the disposal of his body, and at last report, they considered giving it to the Indiana Anatomical Society in Bloomington, perhaps sparing some other poor soul's body from being snatched from its grave by medical students.

14

A Higher Venue

Dallas Bower, twenty-five years old and something of a lunkhead, lived on a farm with his family two miles from New Washington. For reasons now known only to God, he developed a deep dislike for his stepmother, Mrs. Eliza Bower, and he tended to show it through physical violence. He was arrested for assaulting her on September 22, 1911, and taken to nearby Jeffersonville. He paid a seven-dollar fine and went home.

In 1912, Bower was again arrested for beating her. He was not punished, not even fined.

At the beginning of November of the same year, he beat her for a third time. Once more, he got no punishment worthy of the name. It could be argued that the following tragedy resulted from stinginess on the part of the Clark County government. As recently as September, the County Council had refused to appropriate money to cover the expense of taking New Washington prisoners to Jeffersonville; Bower was not arrested after his last outburst because no official wanted to spend his own money to send him to the city. So he was turned loose, and everyone simply hoped he would learn to get along with his stepmother.

Bower's animosity reached its zenith on November 10. His father, Clinton Bower, and brother Benton went outside to do chores, leaving only Dallas and Eliza in the house.

When Benton Bower returned to the kitchen, he found his stepmother lying on the floor, marinating in a pool of blood, "her brains oozing from three ghastly wounds on her head," as a reporter described it. Neither Dallas nor a weapon was to be seen.

Dr. S.L. Adair Jr. was called in. He pronounced Mrs. Bower dying and called the authorities in Jeffersonville. Since Eliza was a goner and there was nothing to occupy the doctor's time until the police arrived, he searched for the object that had inflicted her grievous injuries.

Dr. Adair looked in the family smokehouse, and there stood Dallas Bower. The doctor was surprised, and for lack of anything better to say under the circumstances, he inquired: "Would you mind shucking some corn for me?"

"I don't want to," replied Dallas.

The doctor closed the door and locked it, imprisoning Bower. Word traveled fast in the small community, and soon, the farm was choked with neighbors. A guard was stationed at the smokehouse, implying that some of these villagers desired to see how Bower looked wearing a hempen necktie.

When the police arrested Bower, he offered no resistance and reacted to all questions with a glum, stubborn silence that became his trademark for the remainder of his days. However, he did confess to belaboring his stepmother's head with a hatchet and said he hid it behind a door near the kitchen's firewood box. The bloody implement was found there. The only motive he offered was that he "didn't get along" with Mrs. Bower.

Despite Dr. Adair's gloomy prognosis, poor Mrs. Bower wasn't yet ready to give up the ghost, and she raved with such ferocity—though unconscious—that several men had to hold her down. The doctor gave her opiates to relieve her misery; she spoke, though still insensible, in a garbled and unintelligible fashion. She reached journey's end at noon on November 11, and the charge against Dallas Bower of assault and battery with intent to kill was altered to a charge of murder.

Few news reports about the youthful killer fail to mention his perceived lack of intelligence. From the *Louisville Courier-Journal* of November 12:

> *Bower is a pitiful object to look at, and there is every indication he is not bright. People in the vicinity of New Washington assert he has been feeble-minded all his life. The officers who brought him to Jeffersonville Sunday night assert he did not say five words on the whole trip. On one occasion he acted as if excited and threw his hat out of the automobile.*

Bower refused to eat for over a week. He also did not seem to comprehend the enormity of what he had done.

A special grand jury indicted him on November 14. "Bower still remains silent," said a reporter, "and it is only rarely that he can be induced to even answer questions asked him."

Was he authentically dimwitted or was he shamming? Perhaps a jury would have been convinced that he knew right from wrong and convicted him. He could have been acquitted, jailed or become one of the first to try out the state's newfangled electric chair. We will never know for certain, because while awaiting trial in February 1913, he became ill with heart trouble and dropsy, the old-fashioned name for edema (excessive accumulation of fluid in the body's tissues and cavities). The jail physician said he "may never face the court."

The diagnosis was correct. Bower died on March 5. Had he survived, he was scheduled to go on trial March 14. His last words were, "I am going home." Whether this referred to paradise or perdition was left unclarified, as was the reason why he resented his stepmother so much.

Some anonymous poet of the legal profession made this entry in the docket of the Clark Circuit Court: "Case venued to a higher court."

Bower's tale was told—but there was a postscript. The hatchet murder preyed on the mind of his brother, Benton, who had discovered his dying stepmother, until he could take it no more. In July 1913, he went mad and was committed to the Southeastern Hospital for the Insane at North Madison.

Hypothetical Questions in Abundance

In July 1915, Edmund A.H. Kayser of Gary asked Chief of Police Heintz for permission to carry a revolver. Heintz—who was about to become the most overworked man in town—refused. The chief may have been surprised by the request, because the applicant seemed unlikely to need a concealed weapon. Kayser, age forty-two, was pastor of St. James's Evangelical Lutheran Church at Tolleston, a suburb of Gary. Not long after the chief's rejection, Kayser sent his wife, Dora, and their three children to live with her relatives in Grand Haven, Michigan.

Was Reverend Kayser anticipating trouble? If so, he certainly found it. On the night of August 25, someone standing outside his window shot him in the chest as he sat in his library. He opened the door and was shot in the jugular vein. As he slowly bled to death, his assailant dragged him forty feet from the house, tied his wrists and ankles with window cords and dumped him in a nearby lot, where he was found dead by a passerby an hour later.

H.B. Snyder, postmaster of Tolleston, told authorities that for the past several months, Kayser had received threatening anonymous letters, warnings to stay away from a married Gary woman. Kayser turned a batch of them over to Snyder and requested that federal authorities locate the sender. The *New York Times* reported that a woman's shoeprints were in the dirt outside the pastor's window. Had he been shot by a woman, perhaps the woman mentioned in the mysterious letters? She was located and denied having any untoward relations with Kayser.

The police sneered at suggested romantic entanglements and favored a second hypothesis: there had been strife and controversy in Kayser's church. Allegedly, the pastor received death threats over his highhanded ways. Was the preacher the victim of an angry parishioner? Reverend Conrad Held, pastor of Bethlehem German Evangelical Church, said that several months before, he received a letter complaining about Kayser. The anonymous letter, from Gary, was written in German and was a bitter rant blaming him for "mismanagement of the church, unfairness, persecution of the [Saxon Verein] society, and improper relations with women of the church." Held passed the letter on to Kayser, who had no comment.

A rival theory that never got much traction held that Kayser was slain because of a bad land or business deal. It appears he was in debt and owed many overdue payments.

Then there was a fourth theory, more colorful and topical than the others. Kayser was originally from Württemberg, Germany, and had a Teutonic surname—why, it was virtually *Kaiser*—and of course, in August 1915, Europe was embroiled in World War I. America would not enter the conflict until April 1917, but anti-German feeling was strong in the United States. Yet the foolhardy reverend made no secret of his rabidly pro-German stance, making heated remarks about Russia, France, England, America's neutral policy and President Wilson. He sent letters taking his fatherland's side to German and English newspapers. When some parishioners wrote a statement pledging neutrality, he tore up the document and tossed the scraps in their faces. Worst of all in American eyes, he publicly approved Germany's sinking of the British ocean liner *Lusitania*.

Had Kayser been silenced for making statements considered treasonous by his adopted country? On the day of his death, he informed members of his congregation that an anonymous telephone caller told him he would be "lynched." With a grin, he said he had received so many death threats he didn't take them seriously anymore. Then, he dropped a clue before his listeners that suggested the cause of his death might have been a woman after all: "I have four enemies, and they are the only ones I am afraid of. And if I have trouble with them it will be because of my private affairs. I am not afraid of anything happening because of my political policies." If only he had named those "four enemies"—but he didn't.

Reverend Kayser was buried on August 27, and the mystery of his passing seemed no closer to solution than before. He still had his admirers. The Alliance of German Societies of Evansville, Indiana, sent a wreath bearing the inscription, "To the protagonist of German truth." Later, the same

people would raise a fund to find Kayser's killers. In less than two years, America would be at war with Germany, and these lovers of Kayser and the Kaiser would be as popular as a guy eating beans on a submarine.

Three suspects were collared with fanfare and then sheepishly released. On August 26, Gary police arrested George Schneider for two reasons: he was a member of the Saxon Verein, the church organization that had been at loggerheads with Kayser, and he had scratches and bruises on his face. "Schneider answers the description of the man we have been looking for," said Police Chief Heintz, who, by then, must have wished he had given Reverend Kayser that blasted concealed weapon permit and thereby saved himself a lot of trouble. Schneider protested he had been in a fight and was able to prove it, so Heintz released him.

Thomas Modjesch, an inspector at the Gary Steel Mills, was brought into custody for reasons the police did not reveal to the press. He was soon freed.

Lucas Hamptman, a worker at a steel mill, was arrested on suspicion of being the author of the threatening letters to Kayser. Chief Heintz stated that he believed Hamptman innocent, and the laborer was released.

The leading explanation for Kayser's untimely end was his openly expressed anti-American sentiments. And some believed he was willing to do more to help the German war effort than merely talk. A woman who claimed to have been in the Kayser residence an hour before his death said she overheard a conversation between the reverend and "a prominent Gary attorney," in which they appeared to discuss plans to sabotage the shipment of arms to the European Allies. (The United States was officially a neutral country, but American munitions companies sold explosives to Europe anyway.) They carried on their furtive chat in German, she said.

Joseph Kramer, employee at Gary's Aetna Powder Works—one of the firms that manufactured explosives to be used against Germany—said he was accosted by two men, "one of whom looked something like Kayser," who offered him $1,500 if he would blow up the plant. Kramer was tempted. But patriotism trumped greed, and he refused.

The sabotage theory gained support in Gary on August 29, when a disaster was narrowly averted. Someone noticed that the rivets on a plate holding together two train track rails had been filed. It could have derailed the locomotive, which carried volatile guncotton to be used in the war effort. In addition, the damaged track was located just fifty feet from the Aetna Powder Works, an alleged target of pro-German spies. The press reported that Chief Heintz was "unusually reticent" concerning this development.

Authorities wondered if the attempt at sabotage was connected with Reverend Kayser's murder, but nothing could be proved.

At first, Chief Heintz believed Kayser had been murdered over a woman, not for his politics. However, he came to think that the preacher's rabid pro-German stance was the motive—especially when the chief also started getting death threats in the mail.

Heintz wasn't the only one who thought so. An important announcement came on September 1. Federal and state authorities were convinced that Reverend Kayser's murderers were involved in a "war plot." Since Kayser was virulently pro-German, his assassins must have been anti-German. Said the *New York Times*, "[O]ne or more arrests are expected in a few days." It was suggested that Kayser had been a closet Hun, and not closeted very well:

> *Telegrams and correspondence seized following the murder are said to link the Rev. Mr. Kayser very closely with the German propaganda in this country. Government Secret Service men are investigating rumors that the pastor was plotting to tamper with or destroy mills making war munitions.*

If true, one wonders why pro-German saboteurs would select a notorious loudmouth such as Kayser to do their dirty work. His lack of subtlety would make him less than ideal for pulling off covert operations.

A couple days later, the feds suggested that the undercover sabotage operation in America was bigger than they thought:

> *Gigantic plots in violation of American neutrality, with two organizations of nation-wide extent in every large city, agents for dynamiting powder mills and arms plants, and recruiting officers secretly working in Chicago, New York, Cleveland, and other northern cities have been unearthed by government agents.*

Charles Clyne, United States district attorney, admitted, "There are unmistakably agents of warring governments at work in America." And these revelations were uncovered when authorities investigated the murder of Reverend Kayser. It seems the best thing he could have done for his beloved Germany—not to mention himself and his family—was to keep his big yap shut.

Strangely, after the initial press releases, nothing more was said about this massive conspiracy. The papers did not report on the promised arrests.

Possibly the federal government decided that it was smarter to keep the operations of foreign saboteurs in America a state secret.

Perhaps as a result, Reverend Kayser's slaying remains officially unsolved. On February 19, 1918, Michael Schramm of Bridgeport, Connecticut, confessed to the murder. It appears that no one took him seriously.

16

Thomas Hoal, Boy Bandit

In the late nineteenth and early twentieth centuries, young men were enamored of dime novels. These stories were larded with blood-and-thunder violence, daring rescues, preposterous illustrations and the most stilted language imaginable. And they were very, *very* popular since they were so cheap.

Today, dime novels are valuable collector's items read by few; back when they served as a literary repast to famished adolescents, reformers considered the books vulgar menaces to society and corruptors of youth. Dime novels were blamed for everything from rising crime rates to boys' lack of respect for their elders, and they were roundly denounced, confiscated and banned from coast to coast—which only served, of course, to make them forbidden and even more popular.

Edmund Pearson declared in *Books in Black or Red* and *Dime Novels* that the genre was hokey and harmless; also, rather than reveling in a sense of lawlessness, if anything the stories tended to be as rigidly moralistic as Sunday school primers. Recently, Harold Schechter argued persuasively in his study of the history of violence in American entertainment, *Savage Pastimes*, that dime novels were a convenient scapegoat on which to blame societal pathologies.

But although reformers made too much of the dime novel's influence on young minds, surely a few readers were seduced into committing violent acts by reading them, just as a modern fool might imitate some maniacal stunt he saw in a movie—something that would not have occurred to him unless

the movie put the idea in his mind. It doesn't mean novels or movies are to blame or should be banned, but we should acknowledge that they can put bad ideas into the heads of suggestible souls.

Take the incident of November 11, 1909, for example.

Our story begins in Louisville, Kentucky. A black chauffeur named James R. Tucker, who worked for Mrs. Walter Escott, was cleaning his employer's car in a garage and minding his own business when he was hijacked by a heavily armed seventeen-year-old. The boy ordered Tucker to drive across the river to the Merchants' National Bank on the corner of Pearl and Main Streets in New Albany, Indiana.

Artist's depiction of a rather happy-looking Thomas Hoal in the Jeffersonville Reformatory. *From the Louisville Courier-Journal, November 12, 1909. Courtesy of the Courier-Journal.*

The teenager forced Tucker to enter the bank ahead of him at gunpoint. He made no attempt at subtlety—he toted *five* revolvers and hundreds of cartridges—or even secrecy; he came to the side door just as though he had business to conduct.

When he stood before the tellers' cages, the young man—who would be universally called "the Boy Bandit" in headlines—whipped out two guns from his collection and shouted, "Hands up! Everybody into the vault!" Whether due to inexperience, incompetence or just plain nervousness, he didn't give them an opportunity to fulfill his commands. He started shooting without provocation, first into the ceiling and then at the employees. He shot

94

cashier Jacob Hangary "Gary" Fawcett through the heart and seriously wounded the bank's president, John K. Woodward, in the abdomen. (In one of those bitter ironies that life enjoys throwing at us, Woodward was due to retire in only six weeks.) According to bookkeeper Frank Fougerousse, the bandit didn't even demand money; apparently, he forgot to in the excitement. Then the boy fled the bank without taking a measly penny, dropping one of his revolvers in flight.

"Quick, get me out of here!" the boy ordered James Tucker. Displaying the same foolish impatience as before, the would-be bandit shot the chauffeur in the left side and ran out the door with a pack of policemen and a furious crowd at his heels. They chased him to the river, where he swiped a boat and tried to row to Kentucky. Police caught him, with help from fishermen armed with shotguns, after he was stranded on a sandbar. The mob was in a vengeful humor, and the boy might have had no earthly need for an attorney if the police had not applied some cleverness. The arresting officer instructed the Boy Bandit to feign death; the policeman told the crowd that the shooter had taken poison. The ruse fooled them. The teen was hurried to Jeffersonville Reformatory for his own safety.

In custody, he refused to give his name. He probably marveled at the ease and speed with which he was arrested, since the antiheroes in dime novels never seemed to get caught. However, his silence was in vain. That evening, William J. Hall of 802 South Preston Street in Louisville—an antique dealer, upholsterer and cabinetmaker of excellent reputation—went to the police saying that the bandit's description matched his wayward son, who had not been home for several hours. He added that his son was an incorrigible reader of dime novels, smoker of cigarettes and terrorizer of his own family. He had even beaten his father. Mr. Hall told a reporter, "Now when I see what he has done, I am surprised that he never killed me." He added that his son was so mean and threatening that he was relieved he was being held in the reformatory. When the news got back to the Boy Bandit, he knew the jig was up and revealed that he was Thomas Jefferson Hall.

Except that wasn't the family's true name. It was actually Hoal. William Hall had changed their surname when he abandoned his wife Nettie in Knoxville, Tennessee, several months before. He was trying to escape from an unhappy marriage and did not want her to find him. (They had since reconciled and were living together in Louisville.) The killer shall be called "Hoal" for the remainder of this account.

When the Hoals moved to New Albany from Knoxville in June 1909, they lived across from the bank Tom would attempt to rob in the future.

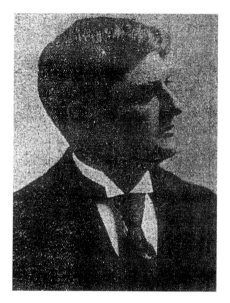

J. Hangary Fawcett, murdered cashier. *From the* Louisville Courier-Journal, *November 12, 1909. Courtesy of the* Courier-Journal.

Undoubtedly living in proximity to the bank fueled his juvenile daydreams about making easy money. The family moved to Louisville in September.

When reporters came to interview Tom Hoal in his cell, they found him stubborn and temperamental. He answered nearly every question with the laconic phrase, "Not saying," and refused to explain why he needlessly shot the workers at the bank, but he was big enough to exonerate James Tucker, whom some thought was an accessory to the crime rather than a hostage: "I'm sorry for what I did, and I know that nobody can help me now. The Negro didn't know what he was doing. I am the only guilty person. I'm not saying why I did it, and I'm not afraid of the consequences." He added, "[Tucker] is square and should be released. He is telling the truth…He couldn't help himself and shouldn't be held responsible."

"Do you read ten-cent novels?" a reporter asked.

"I expect that is the cause of my present trouble," he replied. "I now wish I had let them alone." Thus, Hoal admitted his addiction to violence-prone, outlaw-romanticizing dime novels. (In a later interview, Hoal said of the books, "They had a whole lot to do with it. If I had not read the stories I would not be here." Some would consider Hoal's admission evidence of dime novels' evil influence. But then, it is easier to blame your bad behavior on your choice of reading material than to admit you are an amoral idiot.)

Hoal continued his show of bravado: "They can't [do] more than hang me, and we all have to die."

The journalist interjected, with commendable sarcasm, "Yes, one had to die at New Albany this morning."

"He would not if he had done what I asked him," replied Hoal, glossing over the fact that he had not given his victims the opportunity to follow his instructions.

The condition of the three men shot by Hoal was of paramount concern—or two of them, at least. Cashier Fawcett was beyond help,

having died instantly of his wound. For days the papers reported every peak and valley in the recovery of chauffeur Tucker and bank president Woodward. A headline the day after the shooting announced that Tucker might not survive the day; in fact, he almost died and was saved only by injections of salt water. On November 13, Dr. D.F. Davis said Tucker would develop peritonitis. He did, and it was nearly fatal.

As for Woodward, on November 13, it was said that he had about a fifty-fifty chance for recovery. The next day, the newspapers reported that he was getting stronger. He had serious liver damage, and the doctors predicted that if Woodward could live through the next day, November 14, he would likely survive. On the other hand, they did not hold high hopes for Tucker's recovery.

John Tucker, wounded chauffeur. *From the* Louisville Courier-Journal, *November 12, 1909. Courtesy of the* Courier-Journal.

Mr. William Hoal visited his son at the reformatory the day after the shooting. The heartbroken older gentleman revealed to reporters that when he had briefly worked as a furniture repairman in New Albany, one of his best customers was Gary Fawcett, the man murdered by his son. "I am sorry Tom was not the one who lost his life," he said. "I could have stood it better."

At Hoal's residence, investigators found an enormous, waterproof dry goods box with a hinged door. Mr. Hoal said that his son had threatened the family with death if they looked inside. It contained a five-gallon can of water, a bag of food, a flashlight and battery, a change of clothes (all black), a small bed, guns, three road maps, a railroad timetable, a bottle of matches, a ball of cord, a set of automobile goggles, a mask and a false beard. The outside label read "R.J. Smith, Knoxville, Tenn." Tom Hoal's absurd plan was to escape detection by hiding in the box and having himself mailed away! He must have had an accomplice waiting in Knoxville; otherwise,

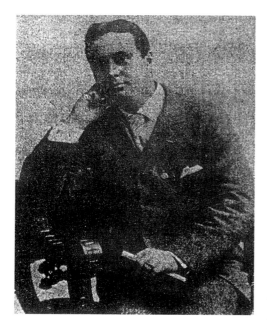

John K. Woodward, wounded bank president. *From the* Louisville Courier-Journal, *November 12, 1909. Courtesy of the* Courier-Journal.

who would have claimed the box? But the mysterious "R.J. Smith" appears not to have been investigated.

Hoal's getaway box proved a source of unending fascination to the public and became a celebrity in its own right. It was taken to Louisville City Hall for safekeeping until the New Albany authorities came for it. Within fifteen minutes of the box's arrival, it drew crowds who wanted to see its ingenious design. A merchant wanted to buy it and put it in his shop window, and a street urchin remarked to a pal, "Say, guy, this here Hoal was the whole cheese. He's got Nick Carter done to a turn." (Judging from his allusion to Carter, hero of many a dime novel, the lad shared his newfound hero's taste in literature.) Officers hauled the box to the police station to prevent souvenir hunters from dismantling it and carrying it away—after all, it was a key piece of evidence.

New Albany police retrieved the box and took it home; somewhere along the way, somebody stole the mask and false beard secreted within. They locked the box in the jailhouse stable, much to the disappointment of anticipating throngs, but put it on display in the yard on December 2. The box's fascination had not waned even by then, and more than one thousand people with nothing better to do turned out to gaze upon it.

The Boy Bandit took hold of the public imagination in a phenomenon that we might call Hoalmania. As Tom Hoal awaited his hearing, he proved an irresistible subject for professional experts and amateurs who wanted to plumb his psychology or present him as a perfect example of all that was wrong with society and modern youth. The *Evansville Journal* and the *South Bend Tribune* ran editorials on the perils of reading dime novels. The *Journal* pointed out that while the hero and the cause of good always triumphed in the novels, the villains could be perceived as worthy of emulation by diseased

minds: "[T]he bad people make just as deep and lasting an impression." There was serious discussion in Indiana about making illegal the sale of "yellow-back novels" (that is, dime novels) through the mail. Postmaster General Hitchcock in Washington, D.C., stated that there was no legal way to prevent their sale as long as they contained no obscene material. He said so regretfully, making it clear that there was nothing he would have loved more than to keep such harmful trash out of the hands of little nosepickers.

Tom Hoal became the subject of many a Sunday sermon. His school records were scrutinized; for instance, Professor J. Milton Elliott of the Dudley Public School in Lexington, Kentucky, which Hoal had attended as a child, noted that the student did well until 1905, when he made poor grades and a teacher described him as "disobedient, untrustworthy, and vicious." Professor Elliott suggested that was when Hoal's downward spiral commenced. Elliott ended his speech by warning parents of their duty to make sure their children read good material.

Hoal's head was also studied. A phrenologist—that is, a brand of quack scientist who claimed he could tell all about a person's character by studying the shape of his head and the bumps thereon—crowed that he had observed Hoal a month before and had boldly predicted that he was certain to rob a bank. Phrenologists were not the only ones to attempt figuring out Hoal's personality and mentality strictly by his looks. Major David Peyton, superintendent of the reformatory where the prisoner was being held, said:

I have examined his head and mouth, eyes and ears, and I think he is the most perfect specimen of a pervert that I have ever seen. His teeth are all jumbled up and not regularly set. His palate is wrongly formed, and he had the mind of an 8-year-old boy instead of a young man of 17.

William Hoal, while not wealthy, persuaded attorneys Laurent Douglas and Samuel G. Wilkerson to save his son from the waiting noose. (Indiana had no law against hanging minors.) On November 13, Tom Hoal confided that he intended to plead insanity. He claimed his mental illness was caused by—wait for it—reading too many dime novels. His bravado had worn off, and his captors described him as cringing and nervous. He no longer seemed so blasé about dying, but he had not conquered his hair-trigger temper.

On November 15, both James Tucker and J.K. Woodward were reported to be "doing better." Doctors confidently stated that Woodward, in particular, had "passed the crisis." The following day, the *Courier-Journal* reported of the bank president, "The danger of death is diminishing every hour that he

lives." The paper said on November 19 that Tucker had entered the valley of the shadow several times but was rescued by "his strong constitution and youth." Tucker finally went home on December 2, in the care of his employer, Mrs. Walter Escott, whose boundless concern for him during his convalescence is one of the few bright spots in the saga of Thomas Hoal. In early February, Woodward went to his home at 511 Park Avenue in Louisville, still in feeble condition.

Hoal's attorneys, undoubtedly secretly relieved that he would be tried for one murder instead of three, asked for a change of venue from Floyd County to Clark County on the grounds that too many people in New Albany wanted to string their client up. He was arraigned in the Floyd County Circuit Court early in the morning of November 24, Thanksgiving Day—so early, by design, that he could be sneaked in and out of the courtroom as quickly as possible before the public found out, such was his unpopularity. In spite of the bank employees who saw him shoot, the hundreds of persons who joined the police in chasing him and his own confession, Hoal pled not guilty.

The change of venue was granted—under Indiana law, the judge could not refuse—and Tom Hoal's destiny would be decided by a jury at Corydon, in Harrison County. With him came his marvelous box—in fact, it arrived in Corydon on January 7, 1910, long before its builder did. Hoal wasn't taken from Jeffersonville until February 19. He spent most of the trip as a little man with a scared look in his eye, quaking in his boots from fear that he would be seized and mobbed. He "trembled as with palsy," wrote one reporter. It was far from the cool, macho image Hoal had tried so hard to cultivate.

Once the prisoner arrived, a problem became evident: the Corydon jail was frail and rickety and would present little challenge to a highly motivated lynch mob. No trouble was expected, but he was strongly guarded just in case and placed in a specially constructed, reinforced cell. He awoke in a funk of fear on his first morning there, having heard the joyful whoops of small urchins playing in the courthouse square and believing that the long-dreaded mob had arrived.

On February 23, while Hoal awaited his trial, the papers reported that a sixteen-year-old boy in Cincinnati was fatally shot by his brother as they enacted a scene from their favorite western-themed dime novel. And on February 27 came news that J.K. Woodward had almost fully recovered.

The trial began on May 4 after an epic struggle to acquire twelve unprejudiced jurors. Two witnesses against Hoal were the men he harmed: James Tucker, who related the story of his abduction and shooting, and J.K. Woodward, who described what happened in the bank that morning. Other

Merchants'
National Bank,
New Albany.
From the Louisville
Courier-Journal,
November 12, 1909.
Courtesy of the
Courier-Journal.

testimony came from C.H. Fawcett, father of the murdered cashier, and former chief of police William Adams, who had rescued Hoal from the mob after arresting him. The defense had only one possible strategy: an insanity plea, for which it laid the grounds by calling its client "mentally defective." To make sure everyone got the point, Tom developed a deadpan expression that made Buster Keaton look like Jerry Lewis and contemplated the ceiling with a glassy-eyed stare. No one had mentioned Hoal's tendency to slip into a catatonic state *before* the trial.

William Hoal was so desperate to save his son from the gallows that he bared a dark family secret in court: his first wife, Tom's mother, had been an alcoholic who drank heavily while pregnant. When the family lived in Lexington, Kentucky, she struck her son on the head with a heavy dish because he hid her whiskey, and after that incident, said Mr. Hoal, Tom was never the same. His son had grown up strong, stubborn and prone to temper tantrums and violence. Oh, and also, he read lots of dime novels.

Also testifying (allegedly) in Hoal's defense was Major Peyton, the reformatory superintendent who had told reporters that he thought the Boy Bandit was abnormal because he *looked* abnormal. Hoal's attorneys expected Peyton to state under oath that he considered Hoal to be insane. But Peyton surprised them by refusing to say so under oath. Instead, Peyton protested that he could say nothing definite about the prisoner's mental condition. The angry attorneys introduced into evidence a letter Peyton had written

A deliveryman standing beside Tom Hoal's celebrated box. *From the* Louisville Courier-Journal, *November 13, 1909. Courtesy of the* Courier-Journal.

to Katie Fox—Hoal's birth mother—in which he opined that his young charge was mentally defective and had been ruined by reading those dime novels.

The insanity plea clearly wasn't going anywhere, so Hoal's attorney S.G. Wilkerson offered a novel alternative theory for the defense: the Boy Bandit fired a warning shot into the ceiling, to be sure, but he didn't kill Gary Fawcett. The teller was shot by *someone else* who fired at Hoal through the window, missed him and *accidentally* shot the cashier. Who was this civic-minded person who shot at Hoal seconds after the bank robber shot into the air? Wilkerson didn't say, nor did his theory excuse the fact that his client also fired at Woodward and Tucker. Reporters noted that Wilkerson's explanation was greeted with broad smiles all around the courtroom. To be fair, Hoal was so manifestly guilty, and his act of violence so senseless, that his attorneys had no choice but to explore the far frontiers of silliness in hope of sparking reasonable doubt.

When the prosecution blistered the Boy Bandit and his deeds in its closing arguments, the "catatonic," "semi-idiotic" Hoal noticeably squirmed.

The case went to the jury on May 6. "At a late hour tonight," dramatically wrote the *Courier-Journal's* correspondent, "twelve grim and troubled men were still wrestling with the question of what shall be done with Thomas Jefferson Hoal."

On May 7, the jury returned with bad news and good news for the defense: it found Hoal guilty (that was the bad news), with a recommended life sentence at the Michigan City penitentiary (that was the good news). A

The *St. Louis Globe-Democrat* did not like dime novels. Reprinted in the *Louisville Courier-Journal*, November 16, 1909. *Courtesy of the* Courier-Journal.

poll of the jurors indicated that they spared Hoal the death penalty only because of his extreme youth. Still, life in prison making the acquaintance of tough convicts was not going to be a carefree existence. Ordinarily, an Indiana prisoner under the age of thirty would be sent to a reformatory, but an exception was made for those convicted of murder.

Rumor held that a lynch mob was in the offing, so Hoal was sent to Michigan City immediately. Before the prisoner was taken away, he again displayed the surly attitude that had gotten him into so much trouble in the first place when Judge William Ridley asked him if there were any reason the sentence should not be passed. A reporter described Hoal's response: "Then, standing before the judge, his body slightly inclined forward, he thundered a venomous 'no.' That one word was the only utterance he made in the courtroom and it contained a world of hatred and disappointment."

It was Corydon sheriff Alva Ward's duty to ride with Hoal to prison. A reporter aboard the train noticed the Boy Bandit's presence, and the sheriff said this to the journalist—in a voice loud enough to make certain Hoal heard every word:

> I had intended to say something good about the boy to the warden of the Indiana State Prison, but he has been so ugly since I started with him from Corydon that I must tell the warden that he is an incorrigible and I hope he will never get out. Before we started from Corydon on Saturday night Hoal got into one of his spells and tore up all of the clothing in his cell. He also tried to break the locks on the door. He is certainly the worst prisoner I have ever handled, but I do not believe he is insane. He will have lots of time to reflect in the State prison during the next ninety-nine years.

After the verdict was announced, the *Courier-Journal* said of Hoal's father: "[He] announced that he would never stop working on behalf of his son until he should be free." Those words were truer than the author knew, because on May 9, the day after Hoal was sent to prison, officials at the Corydon jail found files and five steel saws capable of cutting iron bars in the mattress in his former cell. His father registered surprise and wondered aloud how Tom possibly could have gotten them. The police didn't wonder. On May 19, William and Nettie Hoal were indicted by the Harrison County grand jury for conspiring to help Tom escape. But the pair was nowhere to be found; they had fled to Kentucky, where they vanished as the will-o'-the-wisp at daybreak.

I am sorry to report that the ultimate fate of Hoal's box, like the whereabouts of his parents, is a mystery.

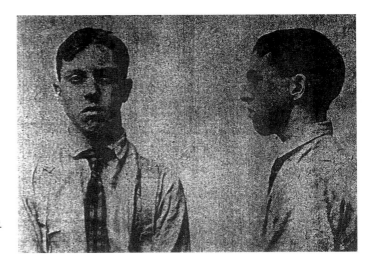

Thomas Hoal's mug shots. *From the* Louisville Courier-Journal, *November 13, 1909. Courtesy of the* Courier-Journal.

The case struck a sour note for nearly everyone involved with it. Hoal's father did not pay his son's lawyers—having disappeared—and they understandably wanted compensation. In September 1910, attorneys Douglas and Wilkerson sent a bill for $528 to the Floyd County Council, but the members refused to appropriate the funds on the grounds that the attorneys had been appointed by a nonlocal judge, Judge Ridley at Corydon; also, there had been no petition for a court-appointed attorney for the young pauper Hoal. In December, their petition was officially denied, and Douglas and Wilkerson had no choice but to eat that $528.

The defense attorneys weren't the only ones who got shafted in the aftermath of the trial. In June 1910, Gary Fawcett's family tried to collect $5,000 worth of insurance from the Travelers' Protective Association for the benefit of the dead cashier's son, Charles. The company argued that Fawcett was not "a regular traveling man," and therefore, his family was not entitled to the money. (Yet they were happy to insure the non-traveling man and thus take his payment in the first place.) Showing the talent for legal hairsplitting that makes insurance companies so beloved everywhere, Travelers' contended furthermore that since Fawcett was a murder victim, his death did not count as an accident. The other side argued that Fawcett's death *was* accidental, since "Hoal was shooting at random without a specific intention to kill him." Attorneys argued the case as late as March 1911; I don't know how it concluded.

Prison conditions were not much to Tom Hoal's liking, and he tried for a parole in March 1912. He sent a letter to prosecutor Walter Bulleit

beseeching his assistance. The letter's elegance and eloquence indicate that while in prison, Hoal elevated his literary tastes. In any case, the attempt was turned down.

Hoal tried again in March 1915, this time seeking aid from Bruce Ulsh, editor of the *New Albany Tribune*. Once again, he blamed his taking the wrong turn in life on dime novels. To show that he had improved himself, Hoal said that he attended prison chapel services and a Bible class, learned the printing trade and played in a band. The *Courier-Journal* remarked acidly in an editorial:

> *That Hoal now plays a cornet and belongs to a Bible class will not be deemed by those who recall the crime sufficient ground for parole…If the murderer of Mr. Fawcett is sincerely religious he should be sufficiently awake to the enormity of his crime to realize that a lifetime of repentance in prison could not atone for it.*

Six months later, on September 27, former bank president J.K. Woodward died at last from the effects of the bullet Thomas Hoal had placed in him nearly six years before.

The aging Boy Bandit got tired of waiting for that parole and decided to take matters into his own hands. On the night of September 22, 1919, he and four other prisoners escaped.

Hoal was never seen again, as far as the record shows. Perhaps he climbed into a well-provisioned box and mailed himself to some exotic location. Undoubtedly, he slumbers far from New Albany under a gravestone bearing a chiseled alias.

17

Three Ways to Escape Punishment

Indianapolis citizens who rose early on Friday morning, February 2, 1934, saw the rare but unwelcome sight of a man's body slumped in a parked car with the motor running. He had been shot in the back of the head but turned out to be no ordinary thug or bootlegger. The victim was none other than Reverend Gaylord V. Saunders, age thirty-six, former pastor of a Methodist Episcopal church in Wabash.

What had Reverend Saunders been doing so far from home? Going to school, actually—embalming school. After retiring from the ministry, he craved a change of careers and had moved to Indianapolis to learn the fine art of giving a pleasantly lifelike appearance to the preserved remains of the dearly departed. His wife, Neoma, chose to stay in Wabash.

Benjamin Franklin once remarked, "Three may keep a secret if two are dead." How right he was. Because of the loose lips of the people involved, the murder was solved by Saturday night.

Reverend Saunders's roommate at embalming school was nineteen-year-old Theodore Mathers. (One imagines their bull sessions must have been pretty interesting, perhaps covering such topics as the efficiency of the trocar for aiding in preservation of the abdominal organs and friendly arguments over whether Cintio or Veino was the superior brand of embalming fluid.) Mathers, in turn, had a lifelong pal named Masel Roe; both Mathers and Roe were natives of Coalmont who had relocated to Indianapolis.

A badly rattled Roe turned informer and told the police that he was present when Mathers shot the preacher: "Several times Mathers told me

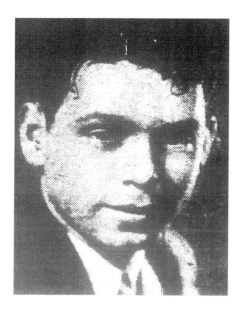

Theodore Mathers. *From the* Wabash (IN) Plain Dealer, *February 5, 1934. Courtesy of the* Wabash Plain Dealer.

that his roommate, Saunders, was nuts and was going to kill his wife and children at Wabash. Mathers said he would rather kill Saunders than see him kill the children."

On the night of Thursday, February 1, Roe and Mathers rode with Saunders down to a tavern called the Brown Derby. Said Roe, "While Saunders was talking with the manager, Mathers told me that he had to 'do it tonight' or kill himself."

(In other words, Mathers considered the reverend dangerously insane, but rather than tell the proper authorities, he thought it better to take matters in his own hands and slay Saunders—and took his mission so seriously that he contemplated suicide if he should be thwarted. The reader may be wondering why young Mathers felt so strongly on the topic of removing Reverend Saunders from the world.)

According to Roe, the three got back in the car—Saunders driving, Roe in the passenger seat and Mathers in the back seat. "Before I knew what had happened, Mathers shot Saunders through the head." Then Mathers took the wheel. After driving around the outskirts of the city for a while with a bloody corpse, they parked. Mathers moved the body to the driver's seat and took the dead man's watch, diamond ring and three dollars from his wallet to make it look like a robbery gone bad. After staging the crime scene, he and Roe lammed it home on foot, but Mathers reassured his old pal that he would "keep Roe's name out of it."

Roe responded, of course, by ratting out his best buddy at the soonest opportunity. After hearing this strange story, the police wanted to get Mathers's side of it. They found him at the freshly minted widow's home back in Wabash. He had gone there, he said, to help her make funeral arrangements.

The reader may be wondering, as did the police, why Mathers took such an interest in the widow of his murdered roommate. He broke down and told Indianapolis chief of police Michael Morrissey that three weeks

before, Mrs. Saunders had paid him a princely $10.00 to polish off her husband—out of which he paid a friend $8.50 for the gun.

Mrs. Saunders and Theodore Mathers were arrested in Wabash and taken to Indianapolis. The police also arrested Masel Roe and Mabel Balke, a nurse who had attended Mrs. Saunders during a bout with tuberculosis, because Mathers said she knew of the murder conspiracy and even had the reverend's watch and ring hidden at her house. (True to his word, these items were found in Balke's basement.)

Once in custody, the four suspects sang like a barbershop quartet. Mrs. Saunders confessed to plotting the murder; Mathers confessed to committing it; Roe confessed to being present when it happened; Balke confessed that she was aware of the impending crime. They were in a predicament, especially the matronly looking, thirty-five-year-old Mrs. Saunders, who admitted that she had masterminded (if that is the correct word) the badly executed, poorly thought-out crime. How could she possibly save herself from Indiana's electric chair?

When a murderer is caught red-handed and has even confessed, he has three available options to escape punishment, and Mrs. Saunders shamelessly employed all three of them.

The first option is the "abuse excuse." She claimed the reverend had been so crazy that she (and Mathers) lived in constant fear. Nurse Balke agreed that Saunders's mind had seemed "affected" in the weeks before Mrs. Saunders decided to put him out of her misery. On the other hand, the victim's brother, Reverend Eldridge Saunders of Uniondale, indignantly denied that Gaylord had had any mental problems.

There is a second option favored by those who commit murder but wish not to be punished: blacken the character of the victim, who is

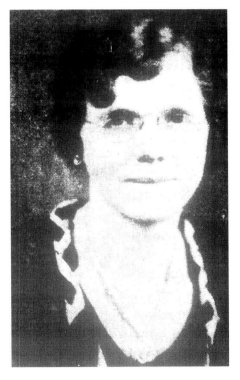

Mrs. Saunders. *From* the Wabash (IN) Plain Dealer, *February 5, 1934. Courtesy of the* Wabash Plain Dealer.

no longer around to defend himself. When Neoma Saunders went to trial on December 7, her defense team made full use of this strategy. In fact, to use its term, Gaylord Saunders had been "a moral pervert." Reverend W. Earl Pittenger offered triple-barreled testimony that Saunders had been a heavy drinker for more than a year before his murder; that he (Pittenger) had urged Mrs. Saunders to have her husband committed because he seemed a "dangerous type"; and that Mrs. Saunders confided to him that Gaylord had subjected her to "indecencies." A family friend, Ross Curts, said that the allegedly deranged preacher had once threatened to kill Mrs. Saunders with a butcher knife; when Curts objected, Saunders bit him on the finger. Prosecutor John Kelly objected to this sort of "mud slinging" and character assassination, but Judge Laymon overruled him.

The prosecution introduced a statement made by Mrs. Saunders in her written confession: "I wanted my husband killed because he was losing his mind and I had papers filed to put him in an insane asylum." She never did explain why she thought it better for him to be dead than hospitalized. When she took the stand on December 13, she denied that she had plotted his death, flatly contradicting her confession.

She also denied under oath that she had been having an affair with young Mathers, as many thought—although that would explain his unnaturally protective attitude toward her, his eagerness to kill her husband and the fact that he was at her house in Wabash when arrested. However, Neoma Saunders was a woman of many contradictions; she quickly reversed course and admitted she had twice scratched the cosmic itch with Mathers. Both times, she said, Gaylord had forced her to do it. Once, he even held a knife to her back!

The crazy man had abused his long-suffering wife in many other ways, she said. He had threatened to kill their two sons; he drank whiskey and smoked cigarettes excessively; forced her to submit to unnamed "unspeakable indignities"; made her look at dirty pictures and read "lewd stories" aloud to him; struck her and threatened her with weapons; and he smoked marijuana, too. This effort to paint the minister as a crazed dope fiend was far more convincing then than it would be now. At the time, marijuana was a relatively new and little-understood phenomenon in American culture, and as everyone in 1934 knew, a couple puffs of this dreadful Mexican weed would turn a straight-A divinity student into a hysterical maniac bent on murder and mayhem, perhaps even cannibalism if the smoker happened to have the munchies.

It should be noted that Mrs. Saunders claimed all of her husband's spectacular dissipation improbably occurred in only the last year or two of his life.

It may have seemed at this point that the defense was overdoing it, but to play it safe it tried a third time-tested possibility for saving its client: the temporary insanity dodge—no, not her husband's insanity, but her own! In other words, if the jury didn't believe Reverend Saunders was crazy, perhaps it could be persuaded that Mrs. Saunders was. The defense's use of this strategy was implied at the beginning of the trial, when prospective jurors were asked whether they believed in *witchcraft*. They also were asked what their attitude would be toward a woman who believed her spouse was possessed by Old Nick himself. The defense claimed that Mrs. Saunders had been driven insane by those undisclosed "unnatural acts of the slain man." (Genuine cases of temporary insanity are rather rare in everyday life—but not in the courtrooms of America.)

Reverend Saunders. *From the* Wabash (IN) Plain Dealer, *February 5, 1934. Courtesy of the* Wabash Plain Dealer.

As we have seen, Mrs. Saunders's attorneys worked overtime to make the minister seem like the living embodiment of depravity and cruelty. (But for some reason, this business about demonic possession was not brought up again.) In contrast to the baroque stories presented by the defense, the prosecution simply said that Mrs. Saunders was a "cold-blooded murderess" with a couple easily discernible motives: she wanted to continue her fling with Theodore Mathers, and she wanted the $29,200 she would receive from Gaylord's insurance policies if he should be so unfortunate as to die an unnatural death.

Three physicians examined Mrs. Saunders and declared her *presently* sane, which meant that if the jury acquitted her, she would be set free immediately.

And that's precisely what happened. On December 18, after two hours' deliberation, the jury returned a verdict of not guilty due to temporary insanity. Mrs. Saunders greeted the verdict with "hysterical laughter"—not *too* hysterical, mind you, as she was supposed to be perfectly sane now. The judge pronounced her free to go.

Masel Roe and Mabel Balke never went to trial; apparently, they got off with a stern warning, perhaps accompanied with the legal equivalent of a dirty look and shamey-shamey fingers.

Theodore Mathers—the self-confessed actual killer of Reverend Gaylord Saunders—went on trial in April 1935. The temporary insanity stunt had worked so darn well for Mrs. Saunders that Mathers's attorneys employed it, too. They argued with straight faces that Mathers had been driven temporarily insane when the reverend forced him to have sex with Mrs. Saunders.

It was a noble effort, but there was one law the attorneys failed to take into consideration: the law of diminishing returns. (Perhaps they also should have considered Murphy's Law.) On April 20, the jury found Mathers guilty of involuntary manslaughter and gave him a sentence of one to ten years in prison.

Bibliography

The Mystery of Dr. Knabe

Dorland, W.A. Newman. *The Sum of Feminine Achievement*. Boston, MA: Stratford Co., 1917.

New Orleans Daily Picayune. "Knabe Murder Case Postponed to Fall." June 24, 1913, 3.

———. "Trial for Murder of Woman Friday." November 24, 1913, 3.

———. "Undertaker and Doctor Accused of Knabe Death." January 1, 1913, 1.

———. "Woman Physician Did Not Suicide." December 24, 1912, 13.

New York Times. "At Bar for Knabe Murder." November 28, 1913, 20.

———. "Buddhism a Clue in Dr. Knabe Case." November 1, 1911, 2.

———. "Clue to Dr. Knabe's Slayer." October 27, 1911, 11.

———. "Deserter Got $1,500 for Killing Woman." April 2, 1912, 1.

———. "Dr. Craig Goes Free." December 10, 1913, 8.

———. "Fails to Identify Craig." December 4, 1913, 2.

———. "Find Woman Doctor Slain in Her Home." October 25, 1911, 7.

———. "Insists He Killed Dr. Helen Knabe." April 3, 1912, 10.

———. "Knabe Verdict Is Murder." December 30, 1911, 2.

———. "New Knabe Murder Theory." November 14, 1911, 4.

———. "No Trace of Knife." October 26, 1911, 9.

———. "Now Think Dr. Knabe Suicide." October 30, 1911, 4.

———. "Seeks Dr. Craig's Acquittal." December 5, 1913, 4.

————. "Sleuths on Knabe Case." February 11, 1912, I, 11.

————. "Sticks to His Story." April 4, 1912, 2.

————. "Sure Dr. Knabe Was Suicide." November 2, 1911, 5.

————. "Was Seeking Flats Dr. Knabe Lived In." October 28, 1911, 20.

————. "Won't Ask Death Penalty." November 30, 1913, II, 14.

PICNIC OF DEATH

Louisville Courier-Journal. "Daughter Testifies in Poison Trial." October 23, 1931, 16.

————. "Eleven on Jury to Try Accused Mother." October 1, 1931, 1.

————. "Food Served at Reunion Kills Sisters." June 22, 1931, 1.

————. "Mother Freed in Poisoning of Girls." May 10, 1933, 10.

————. "Mother Indicted in Poison Case." July 4, 1931, 3.

————. "Mother Quizzed in Poison Deaths." June 23, 1931, 18.

————. "Mother to Be Tried in Poisoning of 2 Girls." September 28, 1931, 11.

————. "Mrs. Simmons to Go on Stand Today." October 28, 1931, 12.

————. "Picnic Poison Case Is Begun." September 29, 1931, 9.

————. "Poison Buyer Put on Stand." October 15, 1931, 1+.

————. "Poison Test Told in Court." October 16, 1931, 29.

————. "Simmons Case Is Given to Jury." November 4, 1931, 1.

————. "Simmons Case Jury, Hung, Is Discharged." November 6, 1931, 1.

————. "Simmons Defense Raps Questioners." October 17, 1931, 3.

————. "Simmons Testifies in Poisoning of Girls." October 2, 1931, 1.

THE FARMHAND AND THE ACROBAT

Louisville Courier-Journal. "Alleged Confession of Wright in Woman's Death Held Competent." March 23, 1934, 14.

————. "Cannelton Prisoner Rushed to Evansville." February 6, 1934, 1+.

————. "Ex-Circus Acrobat Slain in Indiana." February 4, 1934, I, 1+.

————. "Indiana Farm Hand Confesses He Slew Woman Ex-Acrobat." February 7, 1934, 1.

————. "Search for Farm Hand in Slaying of Ex-Circus Performer Widens." February 5, 1934, 1+.

———. "Wright Held Slayer of Ex-Circus Acrobat." March 24, 1934, 1+.
New York Clipper. "The Cherry Blossoms." March 18, 1911, 12.
New York Times. "Farm Hand Gets Life in Killing." March 30, 1934, 7.

MR. WADE AND MRS. BROWN HATCH A STUPID PLOT

Louisville Courier-Journal. "Awful…." September 4, 1880, 1.
———. "The Gallows." October 24, 1880, 2.
———. "Horrible Story of Crime." March 3, 1880, 2.
———. "Indiana." November 26, 1880, 1.
———. "Indiana." January 11, 1881, 3.
———. "Indiana." February 5, 1881, 3.
———. "Indiana." February 22, 1881, 1.
———. "Indiana Affairs." April 30, 1880, 3.
———. "Indiana Affairs." May 1, 1880, 2.
———. "Indiana Legislature." January 8, 1881, 3.
———. "Indianapolis." October 29, 1880, 1.
———. "Indianapolis." December 24, 1880, 3.
———. "Indianapolis." December 30, 1880, 3.
———. "Joe Wade's Story." July 3, 1880, 4.
———. "Mrs. B's Love Story." April 28, 1880, 2.
———. "A Murderer's Poem." July 18, 1880, 1.
———. "A Murderer's Verses." August 19, 1880, 3.
———. "Paralyzed with Horror." July 13, 1880, 1.
———. "Pardoned." March 22, 1895, 5.
———. "A Quiet Man." April 27, 1880, 1.
———. "Waiting for the Gallows." September 5, 1880, 1.
———. "What Love Will Do." April 23, 1880, 4.
———. "Whoppers." July 9, 1880, 1.
———. "Will Mary Brown Hang?" July 11, 1880, 1.
———. "A Wretched Woman." July 8, 1880, 1.
National Police Gazette. "Hoosier Horror." February 21, 1880, 10.
———. "Mrs. Brown Frees Her Mind." February 28, 1880, 3.

A Hoosier Makes a Spectacle of Himself in Cincinnati

Cincinnati Enquirer. "Butcher Murder Is Bared in Cincinnati." March 20, 1933, 1+.

Louisville Courier-Journal. "Man Cuts Wife into 14 Pieces." March 20, 1933, 1.

Hazel Triumphant!

Louisville Courier-Journal. "'Mother' of McNally Doll-Twins is Freed…" October 21, 1922, 1.

———. "Neighbor Testifies…" October 19, 1922, 1.

———. "Strange Doll Case…" December 3, 1922, magazine section, 3.

Pursued by a Monster

Louisville Courier-Journal. "Another Indiana Mystery." Editorial. July 17, 1904, II, 4.

———. "Another Trial." November 4, 1905, 7.

———. "Double Murder May Have Attempted." July 11, 1904, 3.

———. "Gipe Convicted for the Second Time." December 19, 1905, 4.

———. "Gipe Convicted of the Starbuck Murder." December 2, 1904, 9.

———. "Haley Gipe Indicted by the Grand Jury." November 1, 1904, 2.

———. "Haley Gipe Tells of an Alleged Plot." July 26, 1904, 2.

———. "May Be Innocent." March 20, 1905, 10.

———. "Mother and Child Buried." July 12, 1904, 5.

———. "Three More Arrests in the Starbuck Case." August 28, 1904, I, 3.

———. "The Wave of Crime in Indiana." July 24, 1904, II, 8.

Justice, Possibly

Evansville Courier. "At Morganfield." May 20, 1897, 3.

———. "Bloodhounds on the Trail!" May 14, 1897, 1+.

———. "The Buente Murder Case." May 18, 1897, 2.

————. "Lizzie Maria Buente: Funeral Yesterday…" May 15, 1897, 1+.

————. "Patience." Editorial. May 15, 1897, 4.

————. "Perry Township Farmers Take Up Arms!" May 13, 1897, 1+.

————. "Preliminary Hearing." May 16, 1897, 1.

————. "Reach Verdict in Sixteen Minutes." September 29, 1897, 1.

————. "Spaulding Released." May 21, 1897, 1+.

————. "A Strange Negro…" May 17, 1897, 1.

Louisville Courier-Journal. "Arrests of Negroes Suspected…" May 15, 1897, 2.

————. "Blood on His Clothes." May 14, 1897, 2.

————. "Convicted of Attempted Outrage." September 29, 1897, 4.

————. "The Jail Under Guard." May 16, 1897, I, 4.

————. "John Spalding Released." May 21, 1897, 3.

————. "No Mob Came." May 17, 1897, 6.

————. "Outraged and Murdered." May 13, 1897, 3.

THE HONEYMOONERS

Louisville Courier-Journal. "Bullets Fit the Pistol." August 26, 1902, 8.

————. "Charges Mastison with Murder." October 17, 1902, 5.

————. "Continued." November 25, 1902, 7.

————. "Defense of James Mastison Is Outlined by Attorneys." November 30, 1902, I, 8.

————. "Experienced Difficulties in Taking Mastison to Prison." December 15, 1902, 5.

————. "Fear of Gallows Forces Mastison to Confess." December 9, 1902, 4.

————. "For Trial." November 17, 1902, 6.

————. "Held Over." August 27, 1902, 6.

————. "Insanity Will Be the Plea of James Mastison." December 8, 1902, 6.

————. "Insists That an Unknown Man Shot His Wife." August 25, 1902, 5.

————. "Kills Wife in Dry Goods Store." October 8, 1909, 1.

————. "Preliminary Trial Tuesday." August 28, 1902, 6.

————. "Restless." December 10, 1902, 6.

————. "Shot Down." August 24, 1902, III, 1.

————. "To Be Tried." November 24, 1902, 5.

————. "Wife Murderer Gets Life Sentence." October 9, 1909, 1.

WITH A SMILE ON HER FACE

Louisville Courier-Journal. "Arlene Draves' Fall Told Jury." May 15, 1931, 1.

———. "Body of Arlene Draves Exhumed While Curious Throng Watches." March 5, 1931, 1+.

———. "Death Urged for Kirkland." May 26, 1931, 1.

———. "Defense Hails New Draves Witness." March 12, 1931, 1+.

———. "Doctor Avers Hemorrhage Killed Girl." February 27, 1931, 1+.

———. "Eleven on Kirkland Jury 'Mistaken.'" June 7, 1931, I, 1+.

———. "Five Youths Held in Girl's Death." December 2, 1930, 1.

———. "Football Star Sobs Out Story of Love Affair with Dead Girl." March 7, 1931, 1+.

———. "Judge Orders Body of Girl Exhumed." March 4, 1931, 1.

———. "Judge Threatens to Use Jobless for Jury." May 5, 1931, 1.

———. "Jury Sought to Try Youth." February 24, 1931, 3.

———. "Kirkland Accused by Two Friends." May 19, 1931, 1.

———. "Kirkland Given One to Ten Years." May 27, 1931, 1+.

———. "Kirkland in Prison, Case Is Finished." May 28, 1931, 1.

———. "Kirkland Is Given Life Sentence." March 11, 1931, 1+.

———. "Kirkland May Accuse Four Other Youths." April 30, 1931, 1.

———. "Kirkland May Get Jail Term." May 20, 1931, 1.

———. "Kirkland Tells Jury His Love for Arlene." May 23, 1931, I, 1.

———. "Kirkland Term in Gin Death Stands." June 10, 1931, 20.

———. "Kirkland Threat to 'Beat Up' Girl Told." May 16, 1931, 1.

———. "Kirkland Trial Adjourned." May 2, 1931, 12.

———. "Kirkland Trial Is Ready for Arguments." May 24, 1931, I, 1.

———. "Parents Give Kirkland Aid." May 21, 1931, 1.

———. "Parole Given Youth Convicted in Gin Party Death." August 28, 1937, I, 1.

———. "Ronald Oldham Faces New Charge." June 3, 1931, I, 1.

———. "Ronald Oldham Fined for Illegal Practice." August 5, 1931, 1.

———. "Shock of Attack Is Fatal to Girl." December 1, 1930, 3.

———. "State Demands Youth's Life as Kirkland Trial Nears End." March 10, 1931, 1+.

———. "Ten of the Jurors…" Editorial. June 9, 1931, 6.

———. "Two Doctors Lay Arlene Draves' Death to Blow, No Attacks." March 6, 1931, 1+.

———. "Two New Witnesses in Kirkland Trial." May 14, 1931, 1.

———. "Virgil Kirkland Denied Liberty." June 20, 1933, 3.

———. "Waitress Says Gary Boys Bought Hamburgers with Bloody Hands." February 28, 1931, 1+.
———. "Young Kirkland Faces Death or Freedom in Second Trial." May 13, 1931, 1+.
———. "Youth in Gin Slaying Gets Second Trial." April 7, 1931, 1+.

THE STAGE'S LOSS WAS ST. LOUIS'S GAIN

Louisville Courier-Journal. "Boasts of Marksmanship After Slaying Husband." March 3, 1914, 1.
———. "Owsley Jury Unable to Reach Agreement." May 10, 1914, I, 5.
———. "Self-Defense Verdict in Owsley Murder Case." March 4, 1914, 4.
———. "Wife Tried for Death of Former Louisville Man." May 7, 1914, 2.
St. Louis Post-Dispatch. "Defense in Owsley Trial Begins; Wife No. 1 Not Called." May 6, 1914, 3.
———. "Ex-Wife to Testify Against Successor Who Shot Husband." May 5, 1914, 1.
———. "Four Women Freed in Last 3 Years After Slaying Husbands." March 3, 1914, 8.
———. "Husband Slain in Self-Defense, Is Inquest Verdict." March 3, 1914, 8.
———. "Jury in Owsley Case Discharged After 44 Hours." May 9, 1914, 2.
———. "Mrs. Ada Owsley Probably Will Be Tried Second Time." May 10, 1914, 12.
———. "Mrs. Owsley on Trial for Killing Husband." May 4, 1914, 3.
———. "Owsley Case with Jury; First Wife's Story Is Barred." May 7, 1914, 3.
———. "Owsley Jury Said to Be 8 to 4 for Conviction." May 8, 1914, 1.
———. "Wife Who Shot Husband Doesn't Know He's Dead." March 2, 1914, 3.

OTTO EMBELLISHES

(Columbus, IN) Evening Republican. "Attempts Suicide." October 29, 1917, 1.
———. "Husband Sorry His Wife Died." October 30, 1917, 5.

———. "Jury Is Secured for Trial of Murder Case." December 19, 1917, 1.

———. "Otto Vest May Not Be Called for Trial Now." January 31, 1918, 8.

———. "Vest Jury Unable to Agree on a Verdict." December 21, 1917, 1.

———. "Vest Murder Case to Be Settled Very Soon." December 20, 1917, 1.

Louisville Courier-Journal. "Acquittal Verdict Returned." February 6, 1918, 3.

———. "Bride of Month Poison Victim." October 30, 1917, 6.

———. "Faces Trial for Life." December 20, 1917, 6.

———. "Otto Vest Indicted on Charge of Wife Murder." December 2, 1917, I, 8.

———. "Prisoner Breaks Fast After Hunger Strike." November 4, 1917, I, 7.

———. "Prisoner on Hunger Strike." November 1, 1917, 7.

WILLIAM WANTS TO GET MARRIED

Louisville Courier-Journal. "Alleged Parricide Repudiates Confession." January 28, 1912, I, 6.

———. "Boy Who Slew Parents Dies." September 16, 1914, 12.

———. "The Case of William Lee." Editorial. February 3, 1912, 6.

———. "Change of Venue Granted…" December 19, 1911, 1.

———. "Confesses to Killing Father." August 26, 1911, 1.

———. "Defense Will Attempt to Prove Insanity." January 25, 1912, 1.

———. "In Reformatory." August 29, 1911, 3.

———. "Kentuckian on Trial." February 7, 1912, 4.

———. "Lee Pleads Not Guilty…" December 6, 1911, 1.

———. "Lee Pleads Not Guilty…" January 5, 1912, 5.

———. "Lee's Case Expected to Go to Jury…" January 29, 1912, 6.

———. "Lee's Punishment Fixed at Life Imprisonment." February 1, 1912, 8.

———. "Lee to Be Tried on Triple Murder Charge." November 30, 1911, 2.

———. "Mental Taint Pleaded as Excuse for Lee's Crime." January 27, 1912, 3.

———. "Murderer's Lady Love Marries Another." June 25, 1913, 5.

———. "Parole Sought for Man Guilty of Triple Murder." November 23, 1912, 12.

———. "Physician Declares William Lee Sane." January 30, 1912, 6.

———. "Preparing for Defense." September 13, 1911, 12.

———. "Slayer of Trio Gives Details." August 28, 1911, 1+.

———. "State Demands Death Penalty…" January 26, 1912, 2.

———. "Tells Story of Killing Family." August 27, 1911, I, 1.

———. "Triple Murder Charge Against William Lee." December 18, 1911, 4.

———. "Triple Murder Charge Against Young Son." August 25, 1911, 1.

A HIGHER VENUE

Louisville Courier-Journal. "Dies of Wounds." November 12, 1912, 6.

———. "Grand Jury Drawn." November 13, 1912, 9.

———. "Hatchet Used." November 11, 1912, 10.

———. "Inquest Is Held." November 14, 1912, 8.

———. "In Serious Condition." February 27, 1913, 8.

———. "Mind Wrecked." July 13, 1913, 12.

———. "Murder Charge." November 15, 1912, 6.

———. "Prisoner Has Dropsy." February 28, 1913, 10.

———. "Slayer Is Dead." March 6, 1913, 9.

RHETORICAL QUESTIONS IN ABUNDANCE

Louisville Courier-Journal. "Confesses He Murdered Priest…" February 20, 1918, 4.

———. "Death of Gary Preacher Unsolved by Authorities." August 27, 1915, 4.

———. "Evansville Admirers Pay Tribute to Kayser." August 29, 1915, II, 4.

———. "Fund for the Detection of Kayser's Slayers." September 17, 1915, 12.

———. "Gary Letter Reviled Kayser…" August 27, 1915, 4.

———. "Murdered Minister Buried; Death Unsolved Mystery." August 28, 1915, 12.

———. "Pastor Slain; Threatened in Anonymous Letters." August 26, 1915, 10.

———. "Police Chief Receives Threats Against Life." August 29, 1915, I, 3.

Milwaukee Journal. "Kayser Figured in Bomb Plot?" August 28, 1915, 2.

New London (CT) Day. "Church Quarrel Caused Murder." August 26, 1915, 1.

New York Times. "Charge Gigantic Plots to Violate Neutrality." September 3, 1915, 1.

———. "Indiana Pastor Slain After Many Threats." August 26, 1915, 3.

———. "To Wreck Explosives Train." August 30, 1915, 2.
———. "Trailing Pastor's Slayers." September 1, 1915, 20.

Thomas Hoal, Boy Bandit

Louisville Courier-Journal. "After Parole." March 9, 1912, 12.
———. "Alters Name Because of Domestic Troubles." November 13, 1909.
———. "As a Student." November 15, 1909, 2.
———. "Bandit's Victims Recovering." November 19, 1909, 10.
———. "Bank President Is Still Alive." November 13, 1909, 1+.
———. "Bares Sorrow: Father Tells of Wife's Shame to Save Son." May 6, 1910, 2.
———. "Both Victims Doing Better." November 15, 1909, 2.
———. "Boy Bandit Occupies Cell in Reformatory." November 12, 1909, 3.
———. "Boy Bandit's Box Is at Central Station." November 13, 1909.
———. "Boy Bandit Seeks Pardon." March 26, 1915, 10.
———. "Boy Bandit Subject of Lexington School Principal." November 20, 1909, 2.
———. "Boy Bandit's Victim Nearing Recovery." February 27, 1910, I, 7.
———. "Boy Bandit to Be Tried in Harrison County…" December 18, 1909, 12.
———. "Boy Bandit to Plead Insanity." November 14, 1909, IV, 11.
———. "Boy Bandit Will Be Tried at This Term of Court." April 29, 1910, 10.
———. "Cannot Bar Yellow Backs." November 16, 1909, 2.
———. "Change of Venue." November 27, 1909, 3.
———. "Crowd Clamors for View of Bandit's Box." November 14, 1909, IV, 11.
———. "Curious Crowds See Hoal's Box." December 3, 1909, 5.
———. "Denies $500 Fee." December 16, 1910, 8.
———. "The Dime Novel." November 14, 1909, II, 4.
———. "Dime Novels Versus Paroles." Editorial. March 28, 1915, II, 4.
———. "Dramatic Story J.K. Woodward Tells…" May 5, 1910, 2.
———. "Drops Revolver as He Leaves the Bank." November 12, 1909, 3.
———. "Extra Strong Cell Holds Boy Bandit…" February 21, 1910, 2.
———. "For the Curious: Hoal's Box…" December 1, 1909, 5.
———. "Goes to Jury." May 7, 1910, 11.
———. "Hoal Case Goes Over Until May 3." February 24, 1910, 1.

————. "Hoal Case Will Be Called at Corydon…" February 11, 1910, 5.

————. "Hoal Case Will Be Called in New Albany…" November 26, 1909, 5.

————. "Hoal Meets His Son in Prison." November 13, 1909, 1.

————. "Hoal Not Moved: Will Be Kept in the Indiana Reformatory." November 28, 1909, IV, 12.

————. "Hoal's Attorneys Get Nothing." September 9, 1910, 10.

————. "Hoal's Box Sent to Corydon." January 8, 1910, 12.

————. "Hoal's Lawyers Want to Enter an Appearance…" November 17, 1909, 2.

————. "Hoal Still in Reformatory." November 16, 1909, 2.

————. "Hoal's Trial Begins Wednesday." February 17, 1910, 12.

————. "Hoal Trial Delayed at Corydon…" February 23, 1910, 1.

————. "Hopes to Save Neck by Plea of Insanity." November 14, 1909, IV, 11.

————. "Indictments Against Father and Stepmother…" May 20, 1910, 7.

————. "Individual Bookkeeper Tells Thrilling Story." November 12, 1909, 3.

————. "Jury Selected…" May 4, 1910, 5.

————. "Last Ride Taken by Erstwhile Boy Bandit…" May 9, 1910, 3.

————. "Life Sentence Meted Out…" May 8, 1910, I, 3.

————. "Louisville Boy Bandit…Flees Prison." September 25, 1919, 11.

————. "Negro Chauffeur Has Slim Chance to Live." November 14, 1909, IV, 11.

————. "Negro Chauffeur May Not Survive the Day." November 12, 1909, 3.

————. "Negro Chauffeur Tells His Story." November 13, 1909.

————. "Negro Chauffeur Wounded by Bandit." November 12, 1909, 3.

————. "New Albany Banker Shot in 1909…Dead of Wound." September 28, 1915, 8.

————. "Nice Point Raised…" March 15, 1911, 12.

————. "On Trial: Suit Against Insurance Company…" June 16, 1910, 12.

————. "Phrenologist Sizes Boy Bandit Up Right." November 14, 1909, IV, 11.

————. "Physicians Hopeful of Banker's Recovery." November 14, 1909, IV, 11.

————. "Planned to Escape in Shipping Case." November 12, 1909, 3.

————. "Reacting Dime Novel Heroes Boy Kills Brother." February 23, 1910, 1.

————. "Reporter Breaks the News to Boy's Father." November 12, 1909, 3.

————. "School Record of Youthful Bandit." November 14, 1909, IV, 11.

————. "Slip Hoal into Court Secretly." November 25, 1909, 3.

————. "Spirited from Jeffersonville." February 20, 1910, IV, 1.

————. "Steel Saws Found in Hoal's Corydon Cell." May 10, 1910, 7.

————. "They Want $500." November 24, 1910, 6.

————. "Tom Hall, Boy Bandit, Kills Bank Cashier…" November 12, 1909, 1+.

————. "Tucker Taken to His Home." December 3, 1909, 5.

THREE WAYS TO ESCAPE PUNISHMENT

Louisville Courier-Journal. "Four Tell Parts in Preacher's Death." February 5, 1934, 1+.

————. "Jurors Quizzed on Belief in Witchcraft." December 8, 1934, 1.

————. "Jury Given Case of Theodore Mathers." April 20, 1935, 18.

————. "Slain Minister Termed Insane." December 13, 1934, 3.

————. "State Rests in Trial of Mrs. Saunders." December 18, 1934, 4.

————. "Widow and Boy Admit Killing Indiana Minister." February 4, 1934, I, 1+.

————. "Widow Free in Spouse's Death." December 19, 1934, 1+.

————. "Widow of Indiana Preacher Denies She Plotted His Death." December 14, 1934, III, 9.

Reading (PA) Eagle. "Youth Found Guilty of Murdering Pastor." April 21, 1935, 17.

About the Author

Keven McQueen was born in Richmond, Kentucky, and teaches composition and literature at Eastern Kentucky University. He is the author of twelve books, including six for The History Press (*Kentucky Book of the Dead, Strange Tales of Crime and Murder in Southern Indiana, Louisville Murder & Mayhem: Historic Crimes of Derby City, Forgotten Tales of Indiana, The Great Louisville Tornado of 1890, Forgotten Tales of Kentucky*), on Kentucky, Indiana and the deep South, concerning topics such as history, biography, historical true crime, natural disasters and folklore.

OTHER BOOKS BY KEVEN MCQUEEN

Biography/History

Cassius M. Clay, Freedom's Champion (Turner Publishing, 2001)
Offbeat Kentuckians: Legends to Lunatics (McClanahan Publishing, 2001)
More Offbeat Kentuckians (McClanahan Publishing, 2004)
The Great Louisville Tornado of 1890 (The History Press, 2010)

Folklore/History

The Kentucky Book of the Dead (The History Press, 2008)
Forgotten Tales of Kentucky (The History Press, 2008)
Forgotten Tales of Indiana (The History Press, 2009)

Historical True Crime

Murder in Old Kentucky: True Crime Stories from the Bluegrass (McClanahan Publishing, 2005)
Cruelly Murdered: The Murder of Mary Magdalene Pitts and Other Kentucky True Crime Stories (Jesse Stuart Foundation, 2008)
Strange Tales of Crime and Murder in Southern Indiana (The History Press, 2009)
The Axman Came from Hell and Other Southern True Crime Stories (Pelican Publishing, 2011)
Louisville Murder and Mayhem: Historic Crimes of the Derby City (The History Press, 2012)

For further particulars and an entertaining history-based story every month, check out KevenMcQueenStories.com. Friend me on Facebook—I get kinda lonesome sometimes.

Visit us at
www.historypress.net
· ·
This title is also available as an e-book